Color COUTURE

IMAGINE, CREATE AND SKETCH YOUR OWN FASHION DESIGNS

Illustrations by Gloria Collazo
Writing by Catherine Mong

Ulysses Press

Published by:
Ulysses Press
P.O. Box 3440
Berkeley, CA 94703
www.ulyssespress.com

ISBN: 978-1-61243-131-4
Library of Congress Catalog Number 2012951888

Printed in the United States by Bang Printing

10 9 8 7 6 5 4 3 2 1

Acquisitions Editor: Keith Riergert
Managing Editor: Claire Chun
Editor: Lauren Harrison
Proofreader: Elyce Berrigan-Dunlop
Cover design: Keith Riergert and Jake Flaherty
Interior design: Jake Flaherty and Rebecca Lown
Cover illustration: Gloria Collazo

Thanks, Mom and Dad, for everything.

Contents

Introduction

Venture into history and immediately a number of astonishing dresses will take your breath away. Fashion is immersed within every age of history. We've gathered rich and opulent couture gowns, dresses and accessories from the late 19th century to contemporary times to give an intimate look into these handcrafted masterpieces. You can add to history with your own redesigns and colors, sewing the past and the present together.

Vintage Dresses

"Domicilium" Tea Gown

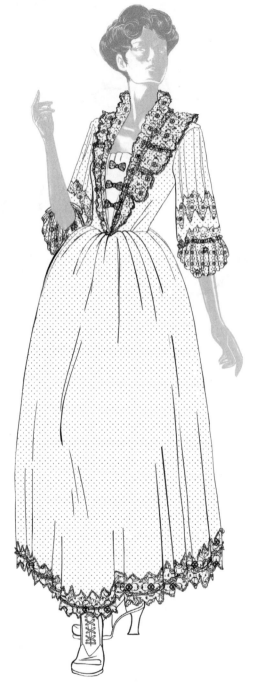

DATE & SEASON
Summer 1880

MATERIALS
Silk organza and lace

INSPIRATION & STYLE
Charles Frederick Worth,
English

Luxurious Eve

*Distancing itself from commonplace corsets
and crinoline structured dresses, this
décolleté gown emphasizes natural beauty,
forgoing the need for tight-laced corsets and
other shape-changing garments. While it is
unsightly to leave the house without either,
this casual gown is ideal for entertaining
family and intimate friends.*

COLOR ME COUTURE

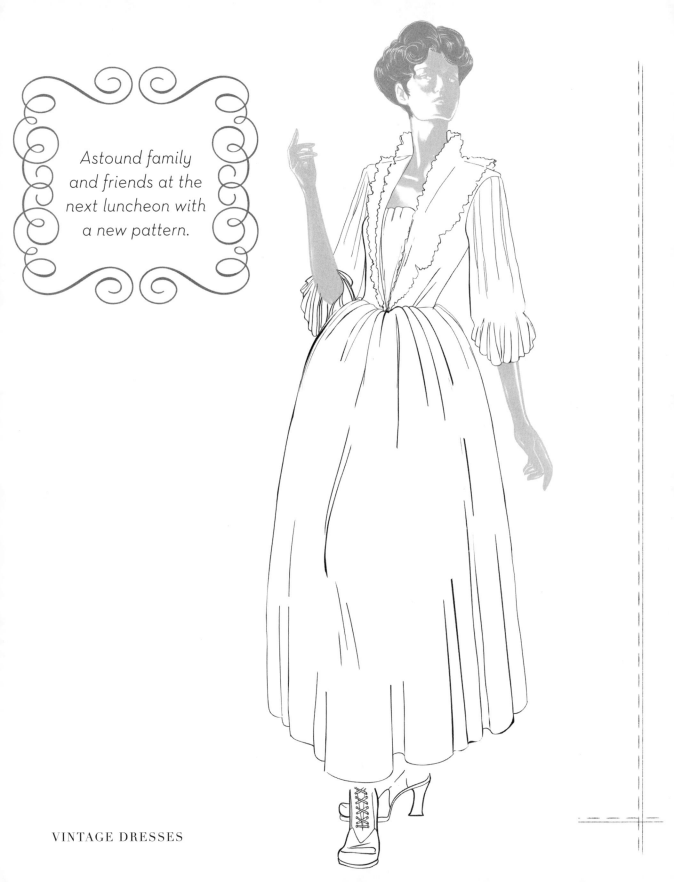

Astound family and friends at the next luncheon with a new pattern.

VINTAGE DRESSES

"Iridescent" Ball Gown

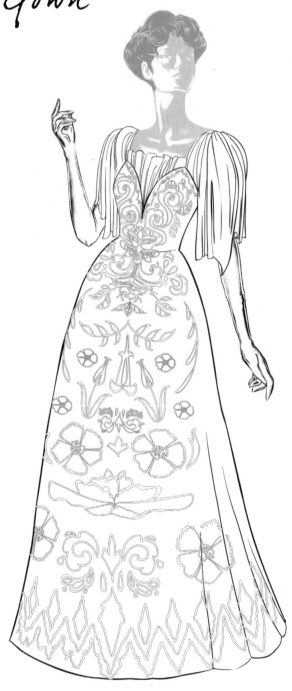

DATE & SEASON

Autumn 1890

MATERIALS & CATEGORY

Velvet and sequin

INSPIRATION & STYLE

Charles Frederick Worth,
English

Velvet Grace

Keep the autumn chills away with this picturesque full-length velvet ball gown. This high-waist gown glistens with thousands of intricate hand-sewn sequin designs and elegant draped chiffon sleeves. No soirée wardrobe is complete without one of these excellent frocks.

COLOR ME **COUTURE**

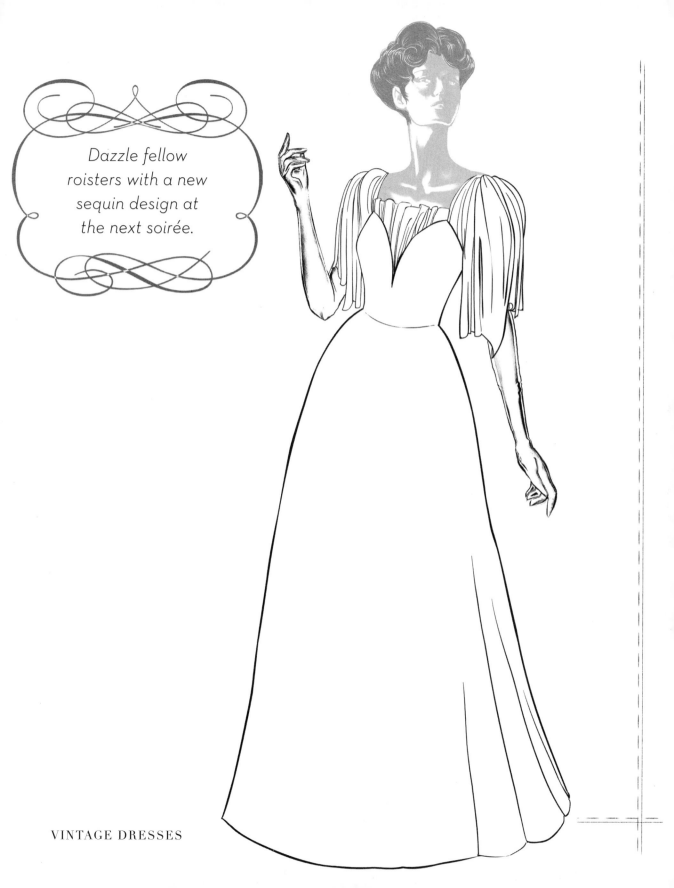

Dazzle fellow roisters with a new sequin design at the next soirée.

VINTAGE DRESSES

"Traversare" Tailor Dress

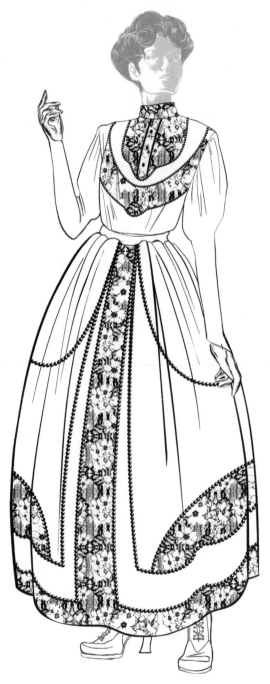

DATE & SEASON

Winter 1899

MATERIALS

Wool, sequin, and lace

INSPIRATION & STYLE

Callot Soeurs, Paris

Gallivant Day

With travel and outdoor activities growing in popularity, day dresses are the choice for informal wear. Here, the leg-of-mutton sleeve debuts alongside the new taper waistline and high-collar silhouette; crinoline is on the decline and is slowly making its way out of high fashion. This ankle-length dress is practical for the winter season while still remaining fashionable with its layer of sequin-laced sheer.

COLOR ME COUTURE

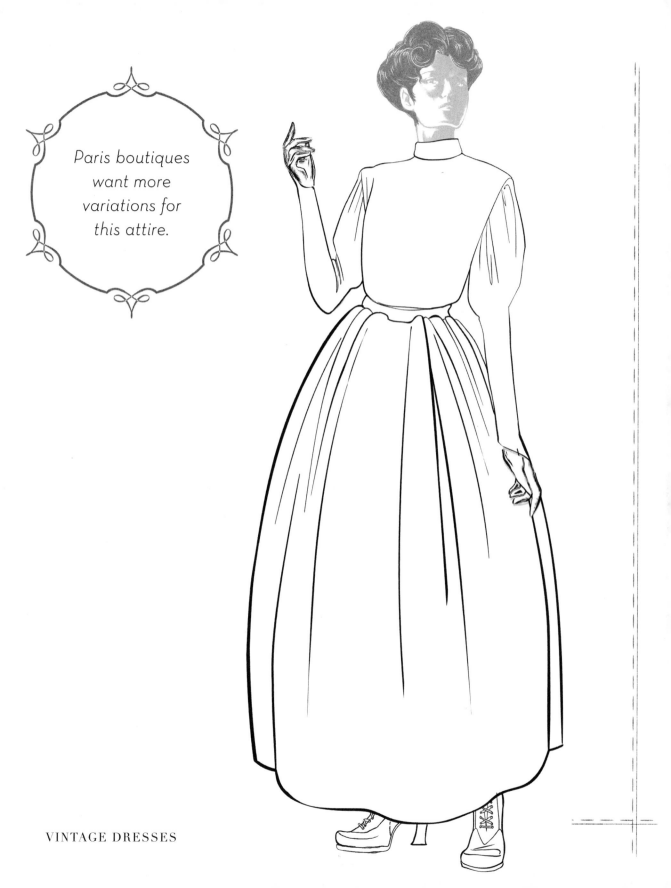

Paris boutiques
want more
variations for
this attire.

VINTAGE DRESSES

"Centrum" Ball Gown

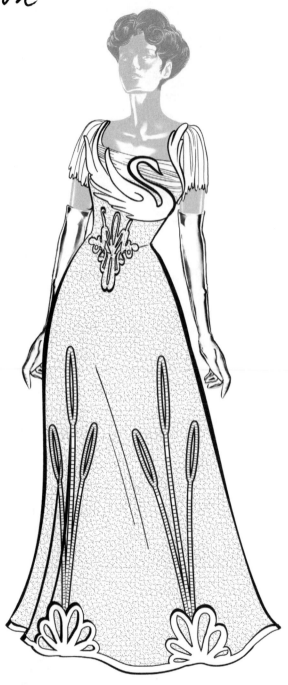

DATE & SEASON
Summer 1900

MATERIALS
Satin, embroideries, and lace

INSPIRATION & STYLE
House of Worth, English

Swan Solstice

Perfect for summer festivities, this formfitting beautify exemplifies lustrous satin sheen. The intricate cattail embroideries throughout the gown create a breathtaking lakeside mirage with a delicate swan adorning the ecru lace bust. Using an S-corset, this curvaceous design adheres to the popular hourglass shape and accentuates the bust and hips.

COLOR ME COUTURE

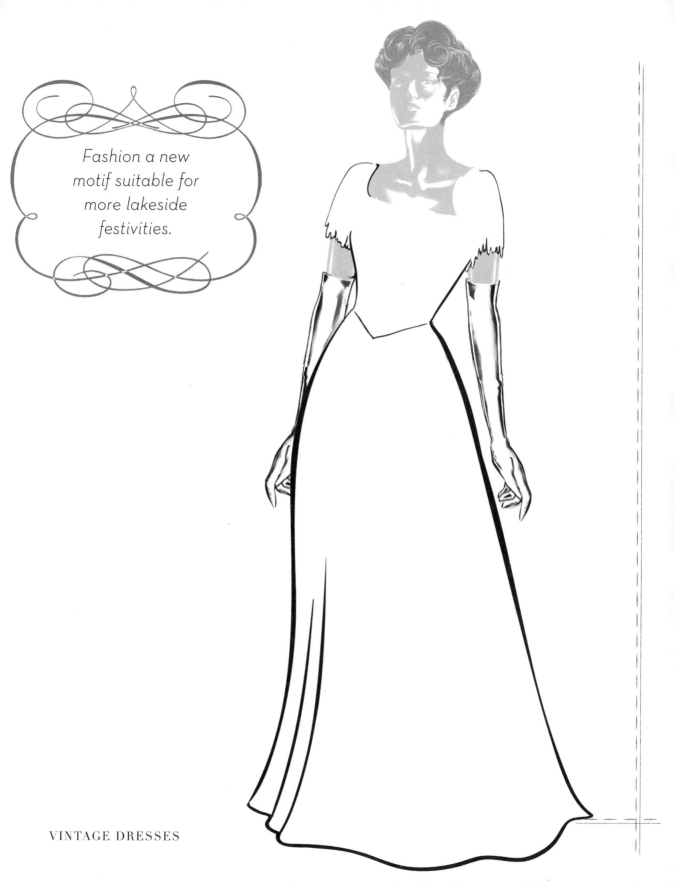

Fashion a new motif suitable for more lakeside festivities.

VINTAGE DRESSES

"Glacial" Ball Gown

DATE & SEASON

Winter 1903

MATERIALS

Chiffon, silk, and embroideries

INSPIRATION & STYLE

House of Worth, French

Exquisite Gala

For a budding debutante, an extravagant ball gown is essential. This winter-silk ensemble is meticulously embroidered with ornate bouquets from its chiffon and silk bodice to its full, sweeping skirt. Fluttering chiffon sleeves add a complementary grace to any debutante strolling toward the evening's first dance.

COLOR ME COUTURE

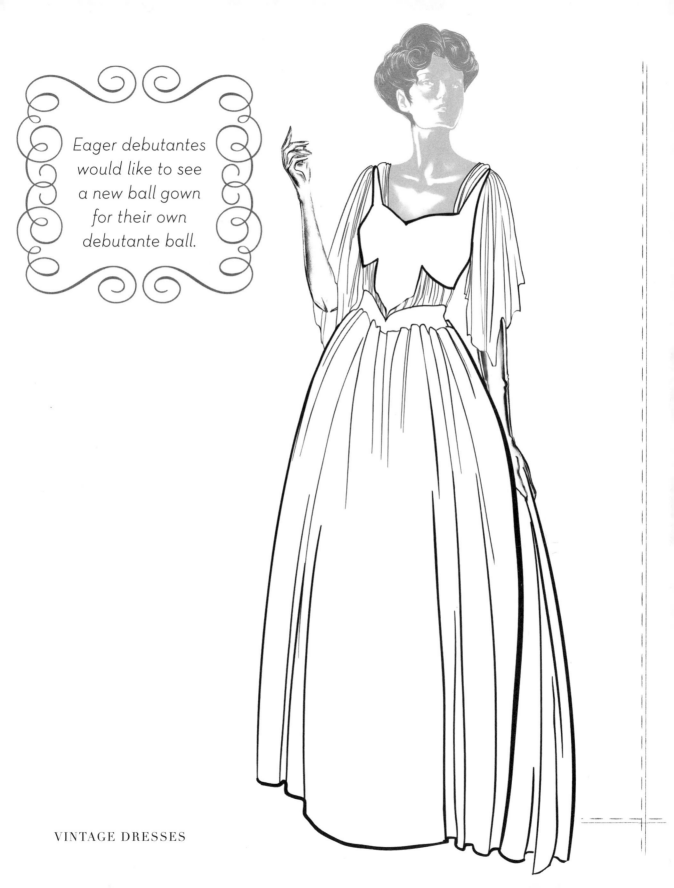

Eager debutantes would like to see a new ball gown for their own debutante ball.

VINTAGE DRESSES

"Edwardian" Evening Gown

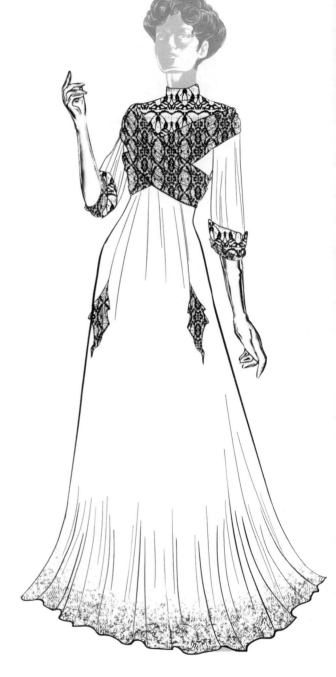

DATE & SEASON
Spring 1904

MATERIALS
Silk taffeta, lace, and chiffon flowers

INSPIRATION & STYLE
Jacques Doucet, French

Dulcet Elegance

Forgoing the hourglass silhouette, this taffeta gown embraces the new season with a je ne sais quoi air with its bust cross-wrapped in layers of taffeta and lace. Alluding to the coming spring, the gown is completed by chiffon flowers and a pooling hem of lace.

COLOR ME **COUTURE**

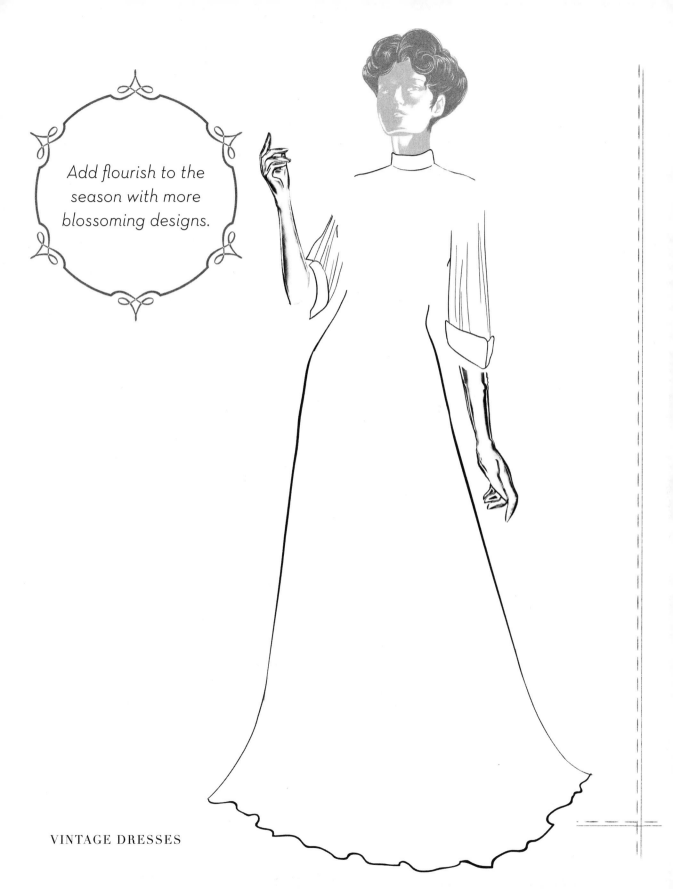

Add flourish to the season with more blossoming designs.

VINTAGE DRESSES

"Vivere" Evening Gown

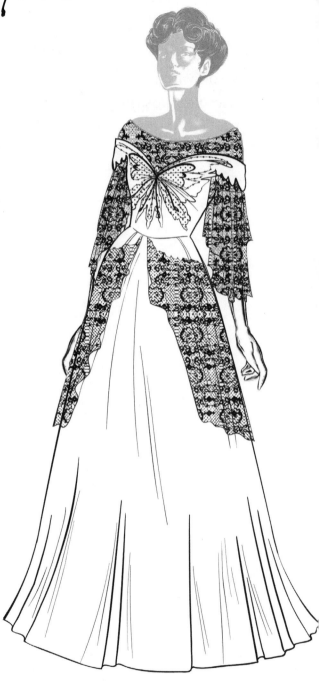

DATE & SEASON

Spring 1904

MATERIALS & CATEGORY

Satin, voile, and sequin

INSPIRATION & STYLE

Jacques Doucet, French

Shy Butterfly

At first glance, the soft interchanging layers of flowery satin and voile give the gown a peculiar patchwork appearance that resembles seasons changing from winter to spring. The open voile sleeves and décolleté collar could match the fabulous Paris Merveilleuses. With the lax waistline and a beautiful sequin butterfly bodice, this gown embraces spring with joie de vivre.

COLOR ME COUTURE

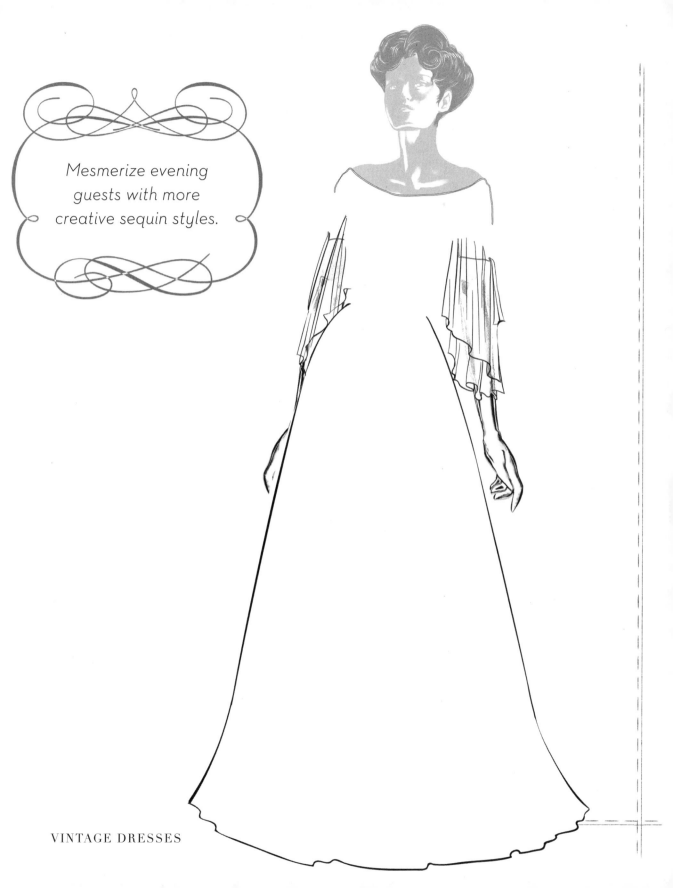

*Mesmerize evening
guests with more
creative sequin styles.*

VINTAGE DRESSES

"Laxus" Afternoon Gown

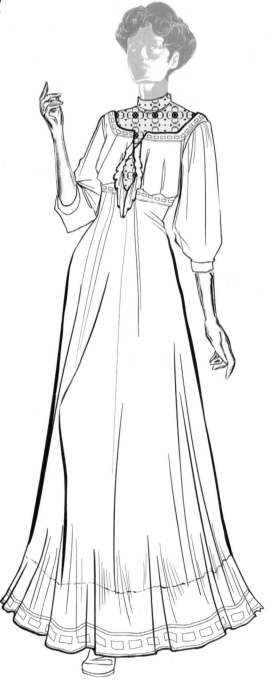

DATE & SEASON

Summer 1905

MATERIALS

Satin, lace, and embroideries

INSPIRATION & STYLE

Jeanne Paquin, French

Casual Outing

Unlike the tea gown, this casual satin dress is modest, with its high lace-collar, and could be worn during a simple outing or afternoon tea with company. The bosom and the leg-of-mutton sleeves are adorned with delicate lace and knotted, stitched embroideries. The flounce-hem gown allows for easy movement and comfort.

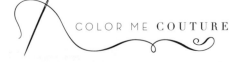

COLOR ME COUTURE

Summertime is ideal for excursions. Design a gown fitting for traveling women.

VINTAGE DRESSES

"Foris" Silk Gown

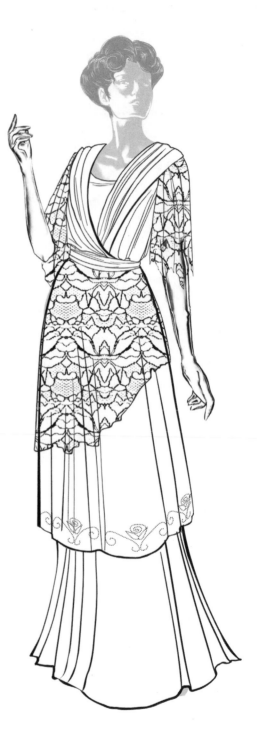

DATE & SEASON

Autumn 1910

MATERIALS

Silk and Chantilly lace

INSPIRATION & STYLE

Paul Poiret, Japanese

Easy Breezy

Interest in the East grew and dresses forwent restrictive corsets and took up Middle Eastern and Asian flair. Influenced by the Japanese kimono, this silk dress follows the wrapping technique to create a V-shaped collar that dips into the bosom while the sash serves multiple purposes in shaping and holding the wrapped fabric in place. The simplicity of overlaying Chantilly lace on the gown's skirt and sleeves gives a clean and refreshing appearance.

COLOR ME COUTURE

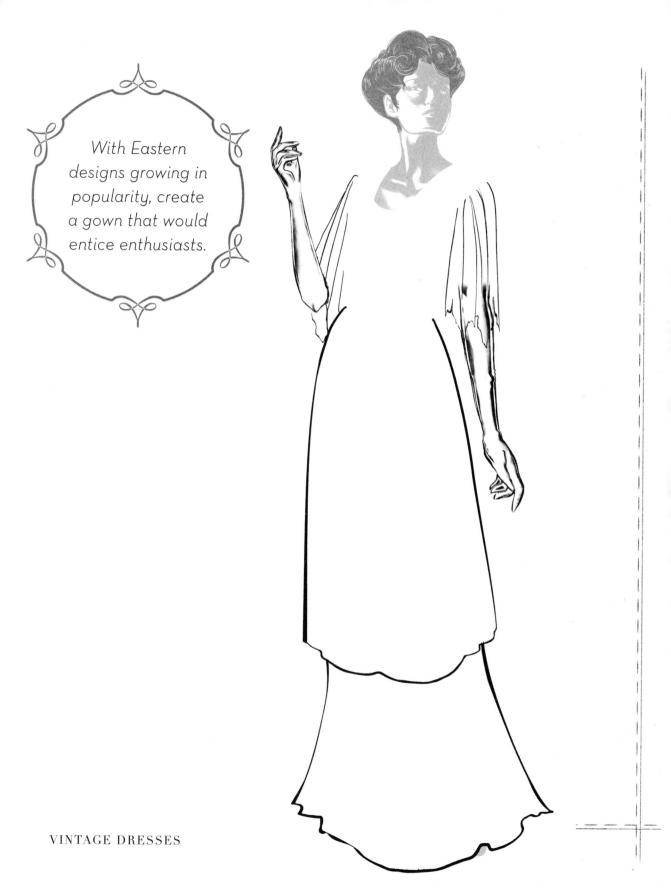

With Eastern designs growing in popularity, create a gown that would entice enthusiasts.

VINTAGE DRESSES

"Grandiose" Evening Dress

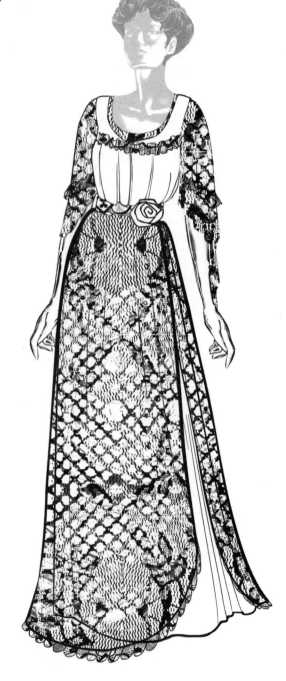

DATE & SEASON

Spring 1912

MATERIALS

Silk charmeuse, satin, Brussels lace and beading

INSPIRATION & STYLE

Callot Souers, French; Middle Eastern

Titanic Voyage

At completion of the Titanic, the biggest and most luxurious ocean liner, those who are bound for its maiden trip find this gorgeous dress irresistible for its Middle Eastern flair and homage to directoire style. This silk charmeuse dress is layered with fine Brussels lace and vinelike seed beadings encompassing the entirety of the dress.

COLOR ME COUTURE

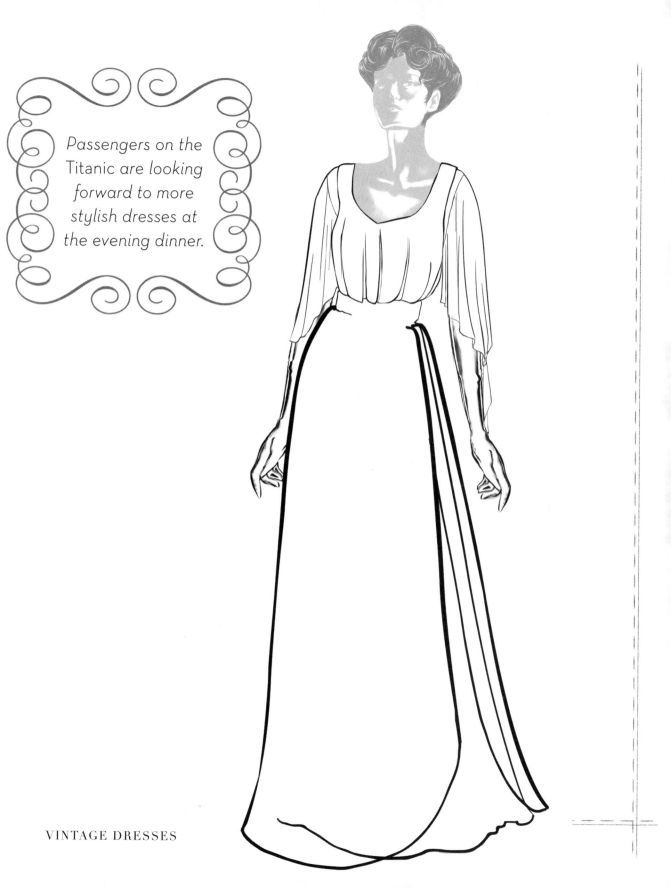

Passengers on the Titanic are looking forward to more stylish dresses at the evening dinner.

VINTAGE DRESSES

"Tunique" French Gown

DATE & SEASON
Winter 1913

MATERIALS & CATEGORY
Silk, batiste, cashmere wool, and brocade

INSPIRATION & STYLE
Georges Doeuillet, Greek

Parisian Winter

Aside from Eastern-influenced styles, tunics overlaying a long underskirt also grew in popularity on the streets of Paris. Keeping to the high waistline, brocades are used instead of sashes for their decorative weave. This high-collar, delicate silk and lace, batiste-layered tunic is popularly worn over a patterned cashmere wool underskirt.

COLOR ME COUTURE

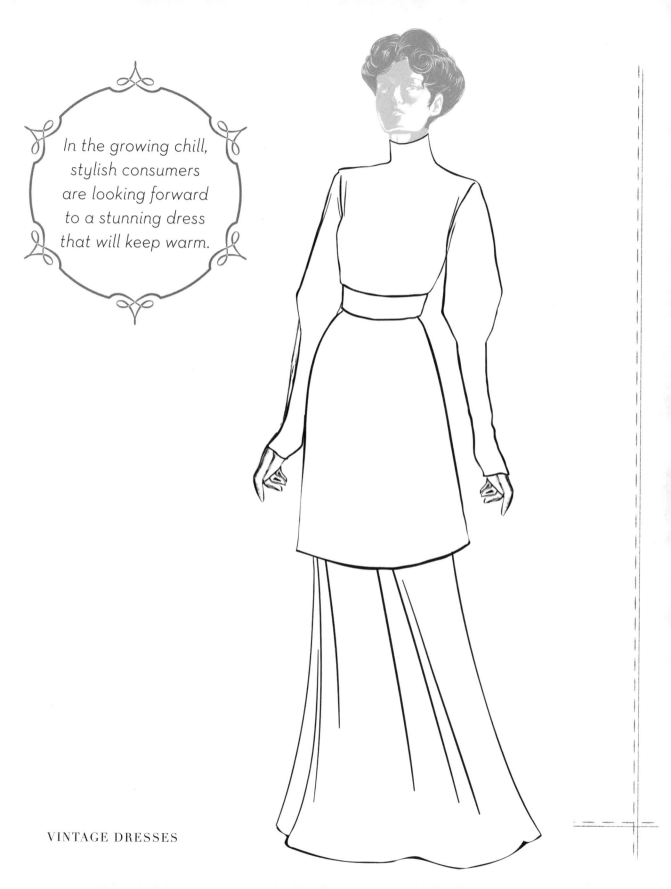

In the growing chill, stylish consumers are looking forward to a stunning dress that will keep warm.

VINTAGE DRESSES

"Seres" Evening Gown

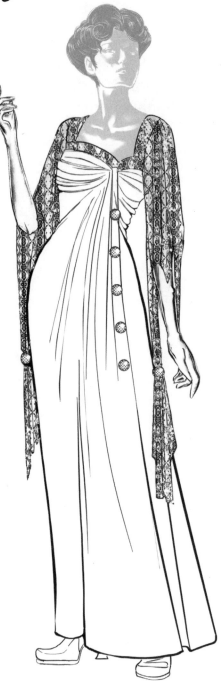

DATE & SEASON

Spring 1914

MATERIALS

Silk, tulle, and rhinestone buttons

INSPIRATION & STYLE

Callot Soeurs, Chinese

Exotic Poise

This alluring silk dress combines the aesthetics of the empire silhouette with the tapered design of the traditional Chinese qipao. Rhinestones are fashionably used as embellished buttons to accompany the earthy texture of the tulle collar and sleeves. Not even the onset of a world war could halt high fashion.

COLOR ME **COUTURE**

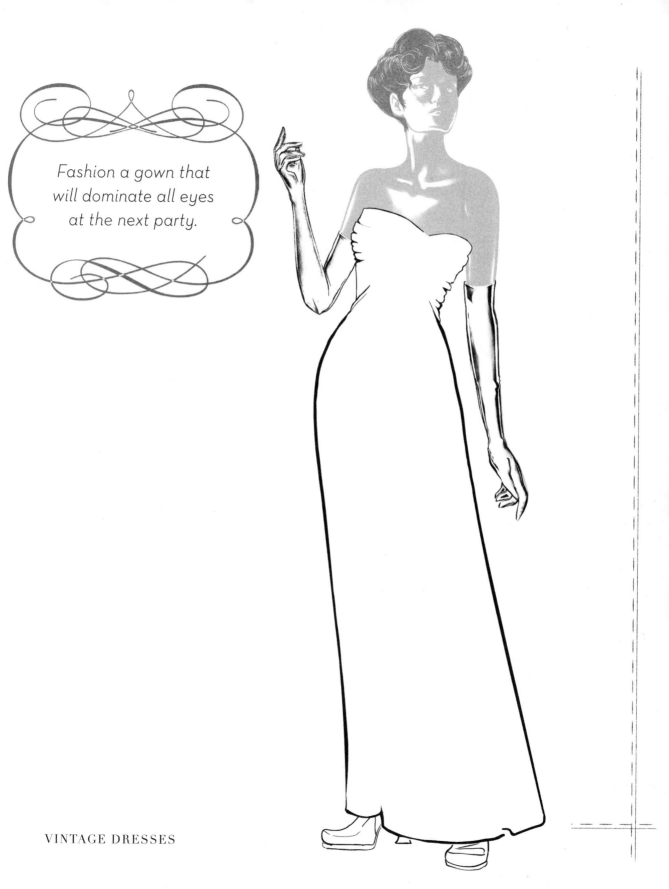

Fashion a gown that will dominate all eyes at the next party.

VINTAGE DRESSES

"Liflic" Evening Dress

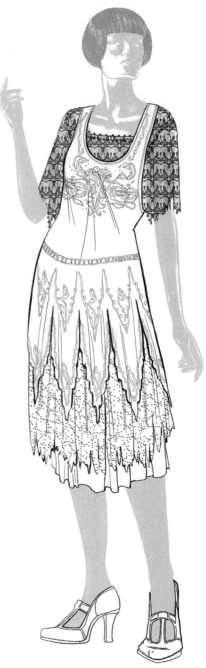

DATE & SEASON
Summer 1920

MATERIALS
Chiffon and beading

INSPIRATION & STYLE
Boué Soeur, American

Full Bloom

Entering the new decade, fashion changed immensely. Gone were the long gowns and in their place came shorter and more convenient dresses. Unlike previously, the handkerchief hem of this bold dress rests barely below the knees, and for the first time dresses are not floor length. Extravagant beading glistens on top the layered chiffon dress alongside a full rose.

COLOR ME COUTURE

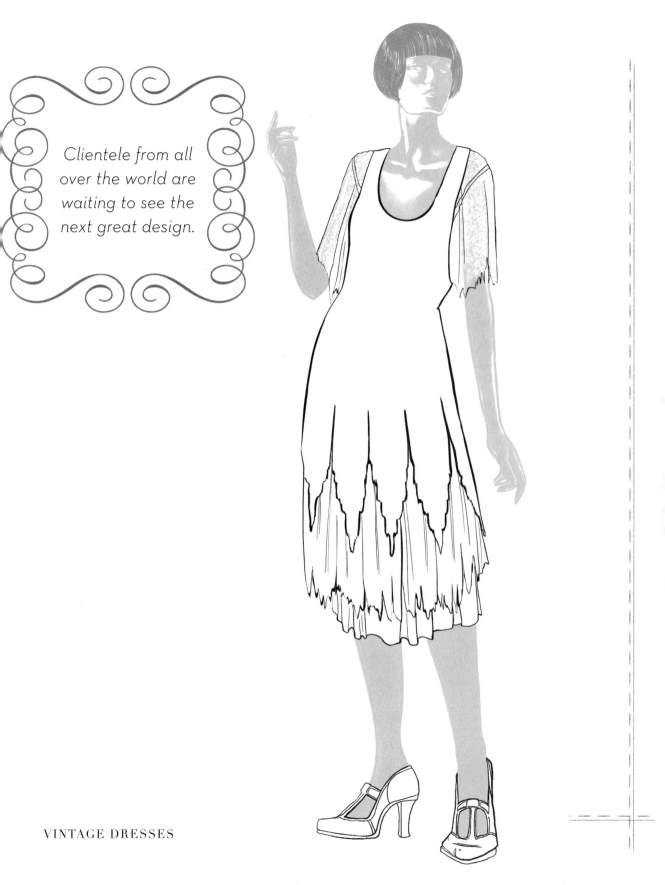

Clientele from all over the world are waiting to see the next great design.

"Deco" Flapper Dress

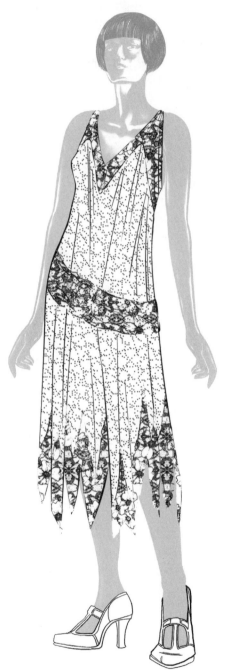

DATE & SEASON

Summer 1923

MATERIALS

Chiffon and sequin

INSPIRATION & STYLE

Jeanne Lanvin, American

Moonshine Glory

With jazz in full swing and the rise in moonshine, short dresses made it easier for wild and exciting dances in speakeasies. Kicking up to the Charleston, this low-cut sequin chiffon dress flutters like flapping wings much like the dress's namesake. Most appropriate for the Roaring Twenties.

COLOR ME COUTURE

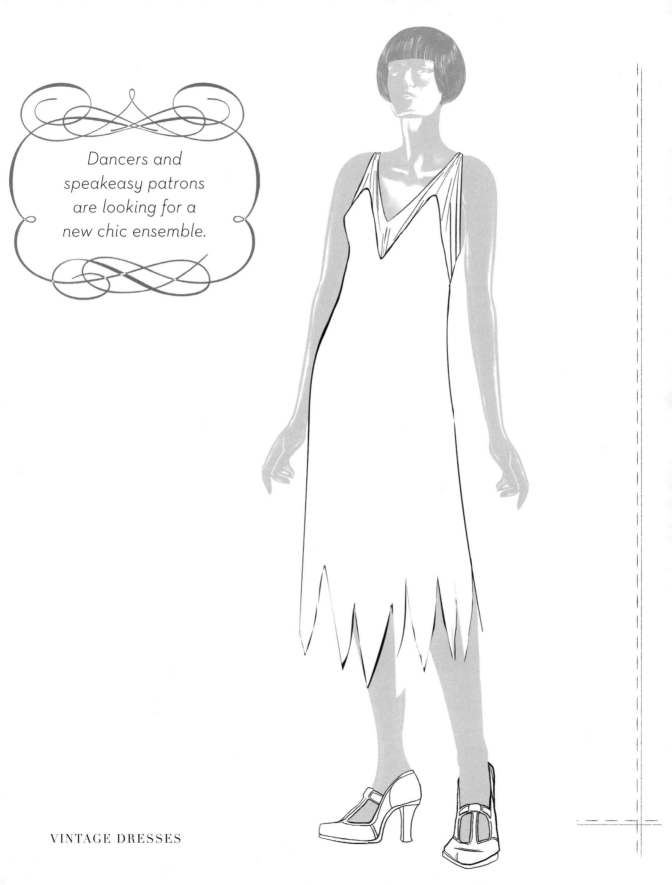

Dancers and
speakeasy patrons
are looking for a
new chic ensemble.

"Polis" Satin Dress

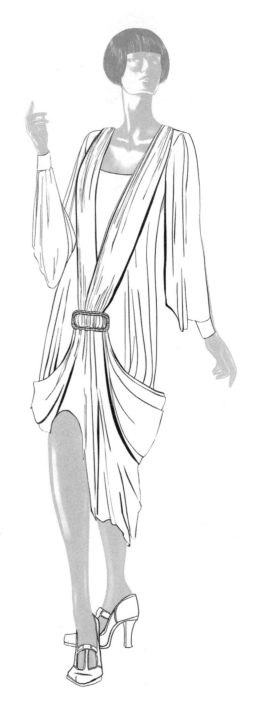

DATE & SEASON

Autumn 1924

MATERIALS

Satin and studded clasp

INSPIRATION & STYLE

Callot Soeurs, Greek;
Roman

Felicitous Change

The women's rights movement leant a hand in rapidly shifting trends, with women preferring more masculine styles that gave little definition to the natural feminine curves. This loose satin dress is held together by a studded clasp; the lack of curve definition leads way to a boyish physique reminiscent of the fluid draping in clothing from ancient Greek and Rome.

COLOR ME COUTURE

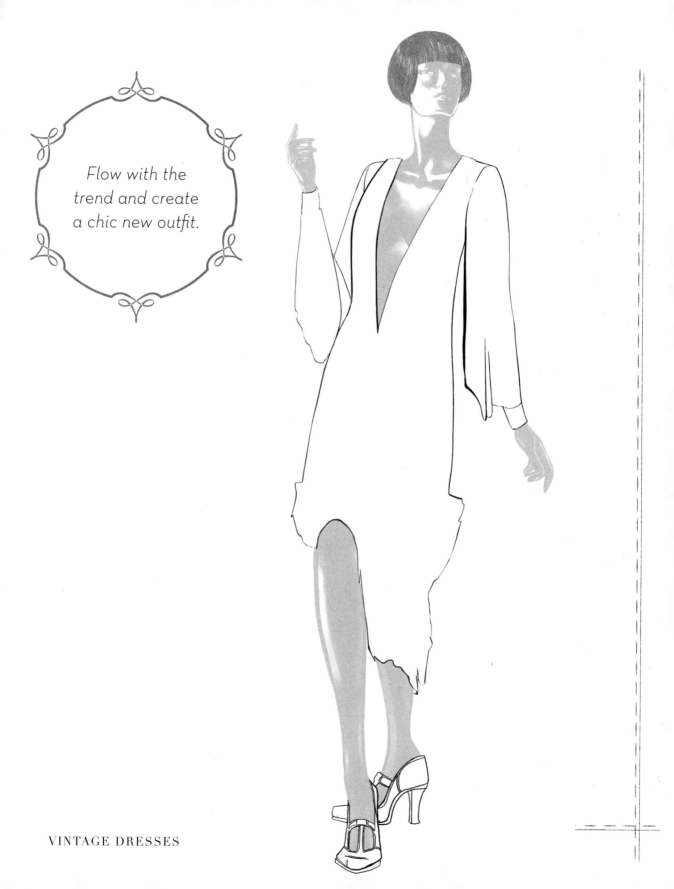

Flow with the trend and create a chic new outfit.

VINTAGE DRESSES

"Glaes" Evening Gown

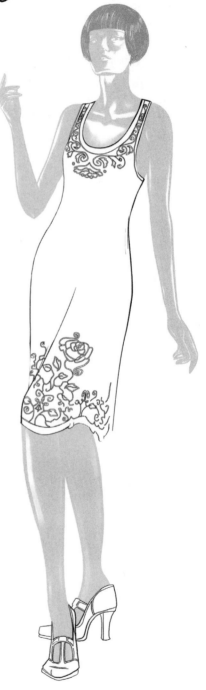

DATE & SEASON
Summer 1925

MATERIALS
Silk and glass beads

INSPIRATION & STYLE
House of Worth, French

Theatre Rendezvous

Dating without the company of chaperones emerged, with more and more young women and men casually accompanying one another to dinner and other evening activities. With its suggestive slit at the side and a matching glass-beaded train, this sleeveless atlas dress is excellent for a tête-à-tête evening.

COLOR ME COUTURE

*Love is in the air—
amorous couples are
looking for charming
attire for a night out.*

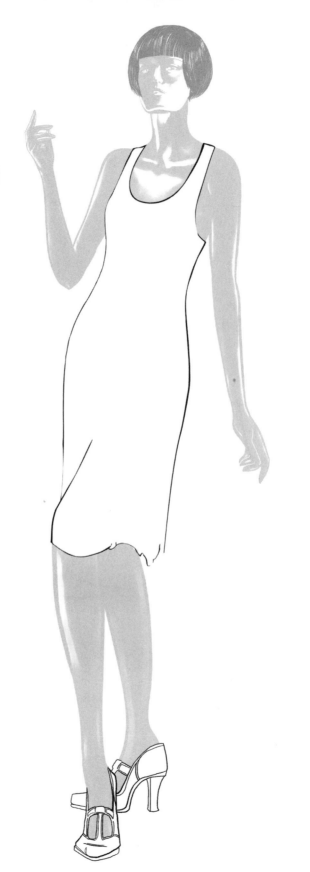

VINTAGE DRESSES

"Feuille" Frock

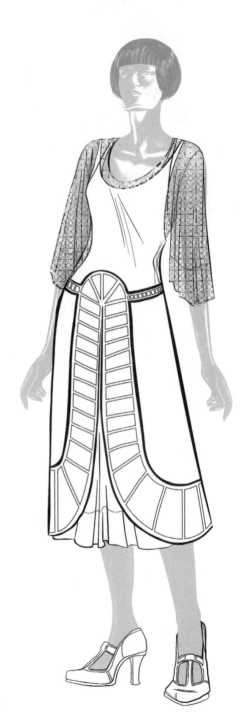

DATE & SEASON

Autumn 1925

MATERIALS

Chemise, batiste, and lamé

INSPIRATION & STYLE

Jeanne Lanvin, French

Simple Threads

Even in the cooling seasons, short dresses still dominate everyday wardrobes. This chemise dress is layered with batiste and accentuated with a glossy metallic lamé trim over the petal-like tiered skirt. This casual skirt could be worn daily, be it for an outing or a friendly gathering.

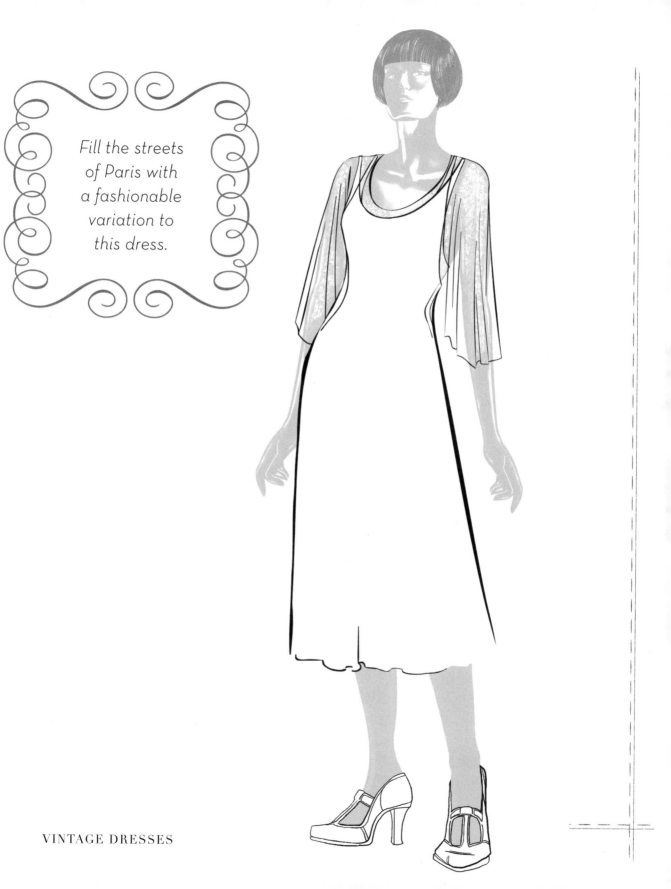

Fill the streets of Paris with a fashionable variation to this dress.

VINTAGE DRESSES

"Celebutante" Evening Dress

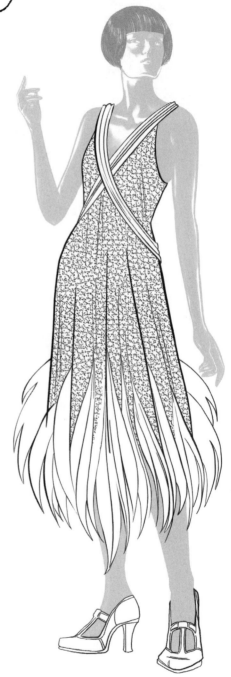

DATE & SEASON
Spring 1927

MATERIALS
Sheer and feathers

INSPIRATION & STYLE
Peggy Hoyt, American

Starlet Night

Hollywood hosted the first of many annual Academy Awards in 1927 as it became world-renowned for its surge of artistic silent films. This striking crepe dress astounds the red carpet with its feathery hem and scandalously low-cut collar. The thin layers of sheer cross-wrapped at the bust only serve to draw all eyes to the décolleté dress.

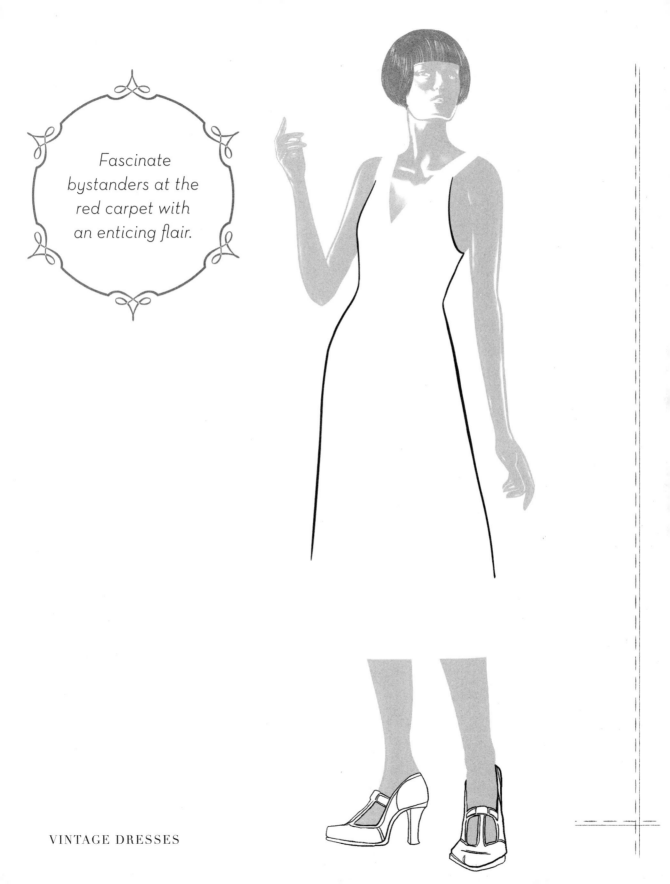

Fascinate bystanders at the red carpet with an enticing flair.

VINTAGE DRESSES

"Nostos" Day Dress

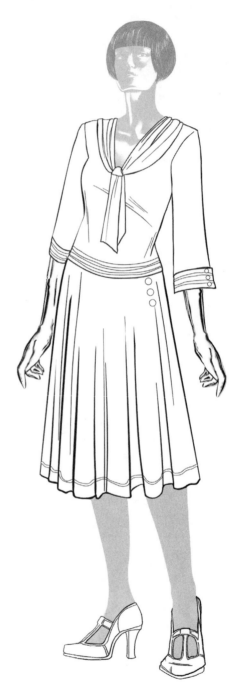

DATE & SEASON

Spring 1927

MATERIAL

Cotton

INSPIRATION & STYLE

House of Worth, English

Springtime Youth

With risqué dresses dominating evening activities, this modest cotton dress was a refreshing change for a casual day outing. The striped cuff and knotted scarf give off a fun and youthful air reminiscent of sailor suits worn by young boys, while the pleated skirt allows for freedom of movement.

COLOR ME COUTURE

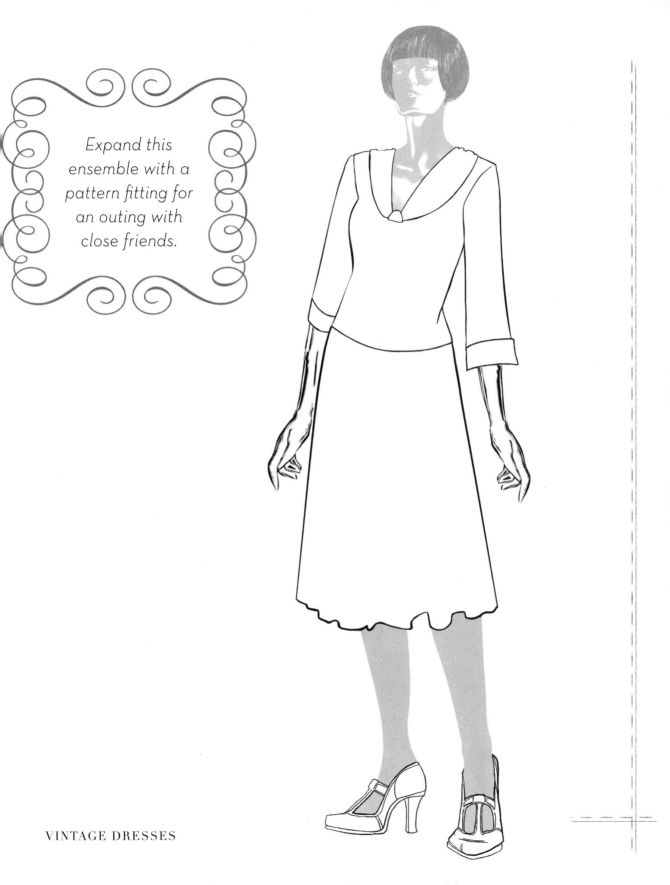

Expand this ensemble with a pattern fitting for an outing with close friends.

VINTAGE DRESSES

"Oceanic" Evening Gown

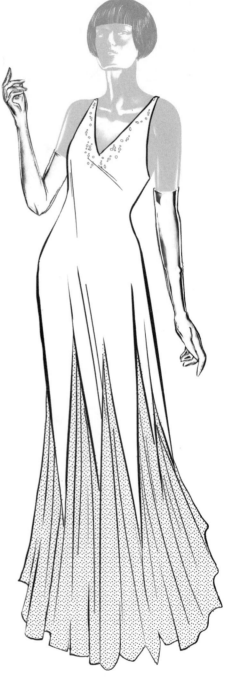

DATE & SEASON
Summer 1929

MATERIALS
Chiffon and sequin

INSPIRATION & STYLE
House of Worth, English

Maiden's Peak

With the rise of haute couture, fashion shows became commonplace outside of Paris. However, this does not diminish the magnificence of this chiffon evening gown. The mermaid silhouette made its first debut with its form-hugging bodice and flared mermaidlike skirt. The glittering sequin complements the dress with its resemblance to scales.

COLOR ME COUTURE

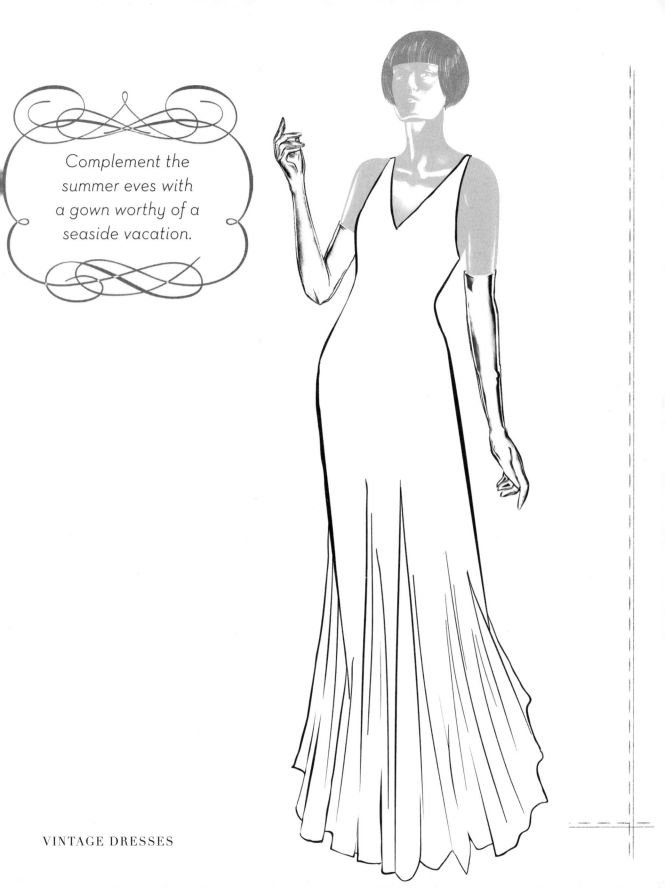

Complement the summer eves with a gown worthy of a seaside vacation.

VINTAGE DRESSES

"Eligere" Dinner Dress

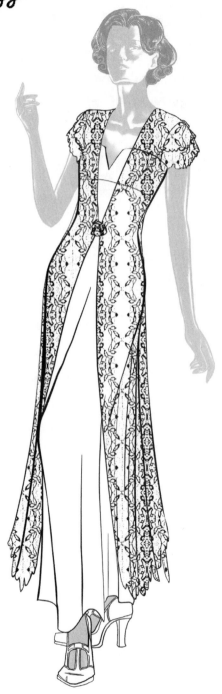

DATE & SEASON
Autumn 1930

MATERIALS
Cotton and lace

INSPIRATION & STYLE
Jeanne Paquin, English

Modest Sophistication

The crashing stock market and the onset of the Great Depression affected many and leant a hand in fashion's move away from short flapper dresses. This A-line silhouette dress brought back the womanly shapes that were disregarded in the previous decade and a return to dresses of modest lengths. Adorning this strapless cotton frock is a tasteful lengthy lace coat that enhances the fluid gown beneath.

COLOR ME **COUTURE**

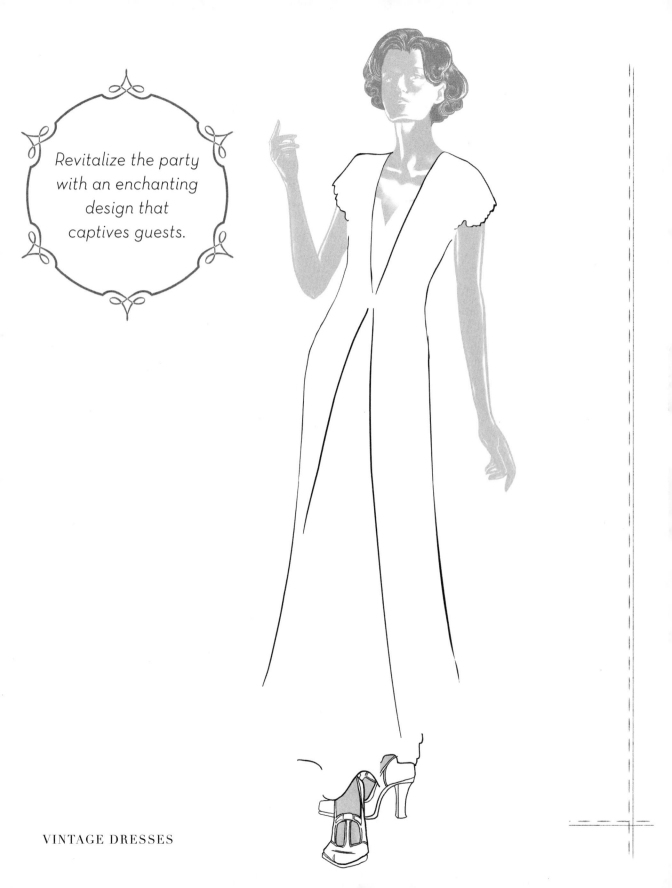

Revitalize the party with an enchanting design that captives guests.

VINTAGE DRESSES

"Fluere" Rhinestone Dress

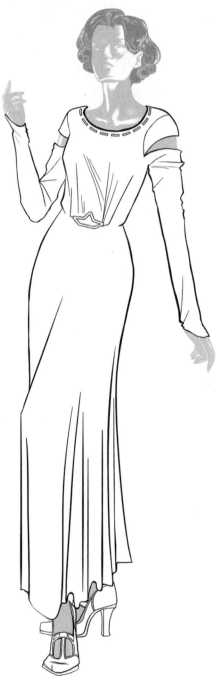

DATE & SEASON
Winter 1931

MATERIALS
Velvet, silk, and rhinestones

INSPIRATION & STYLE
Gilbert Adrian, English

Affluent Silhouette

With the economy's decline conservation became the concern for many; however, that was no excuse for a shoddy wardrobe. This elegant velvet dress, embellished with a rhinestone belt and silk collar, is ideal for keeping up appearances. The open sleeves give versatility, allowing the dress to be worn in both cool and warm seasons.

COLOR ME **COUTURE**

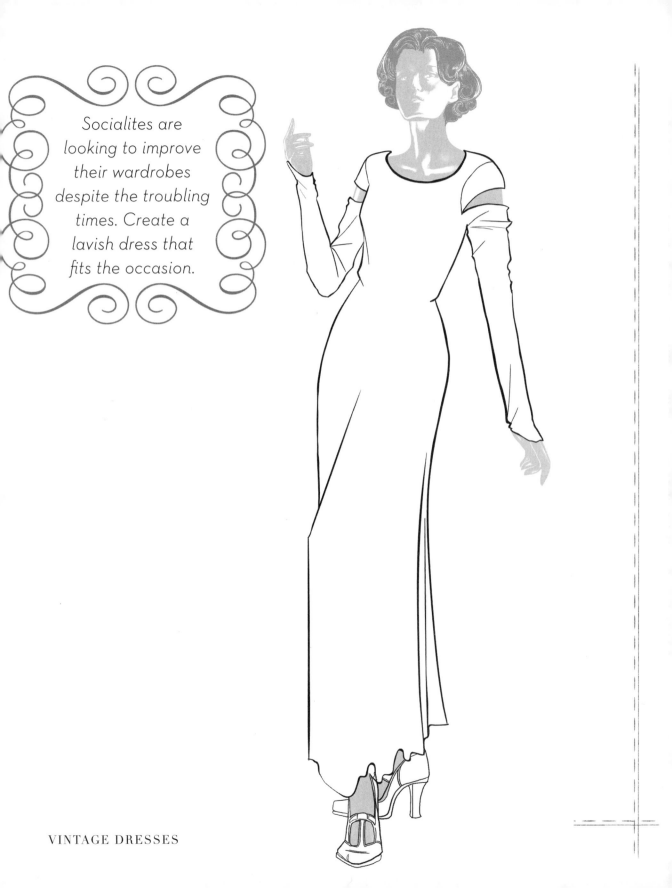

Socialites are looking to improve their wardrobes despite the troubling times. Create a lavish dress that fits the occasion.

VINTAGE DRESSES

"Radiance" Satin Dress

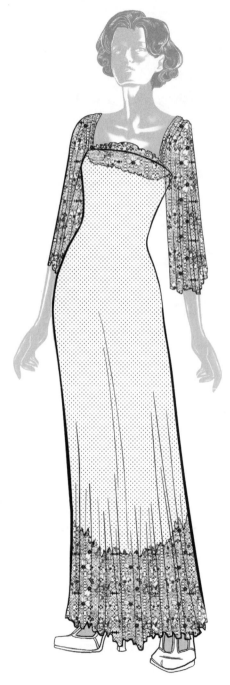

DATE & SEASON
Summer 1932

MATERIAL
Satin and lace

INSPIRATION & STYLE
Coco Chanel, French

Midnight Line

Minimalist designs abounded to compromise between fashion and the growing financial difficulties. The fine lace overlaying this satin dress gives a much-desired dishabille appearance. While keeping far from the risqué styles of the '20s, this racy dress could still garner plenty of attention.

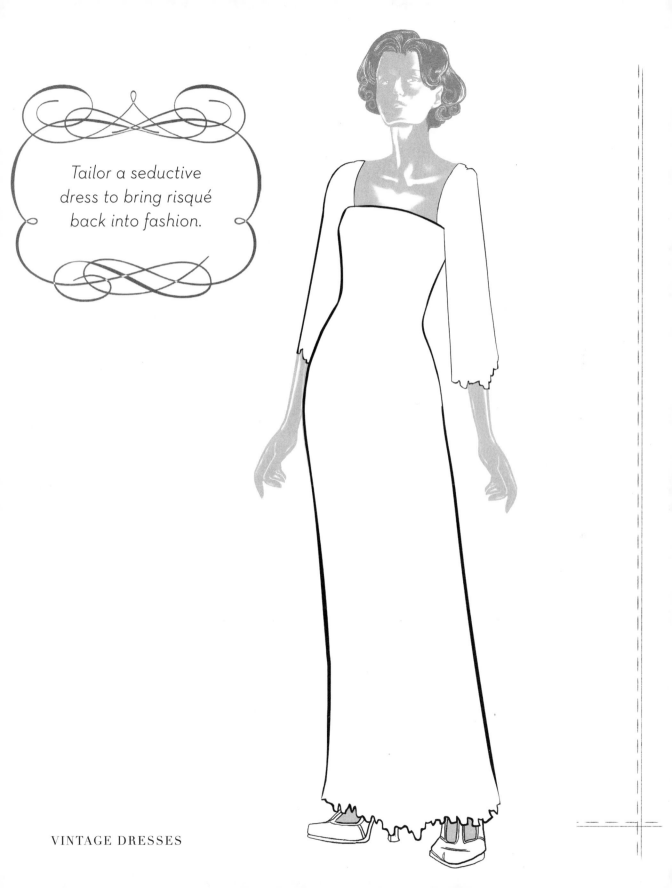

Tailor a seductive dress to bring risqué back into fashion.

VINTAGE DRESSES

"Menrva" Evening Gown

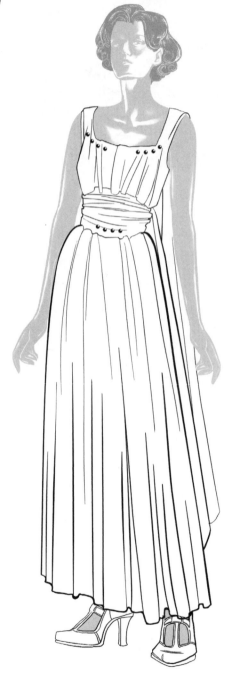

DATE & SEASON

Summer 1937

CATEGORY

Batiste

INSPIRATION & STYLE

Madeleine Vionnet. Greek

Athenian Cascade

As Hollywood stepped into its Golden Age, film costumes were a great influence to couturiers as garments from various time periods were romanticized on the silver screen. Utilizing the bias-cut technique, this batiste gown's soft draping is similar to that of Grecian clothing. The flowing thick sash tied under the bust to the waistline complements the flowing gown and emphasizes the body's curves.

COLOR ME **COUTURE**

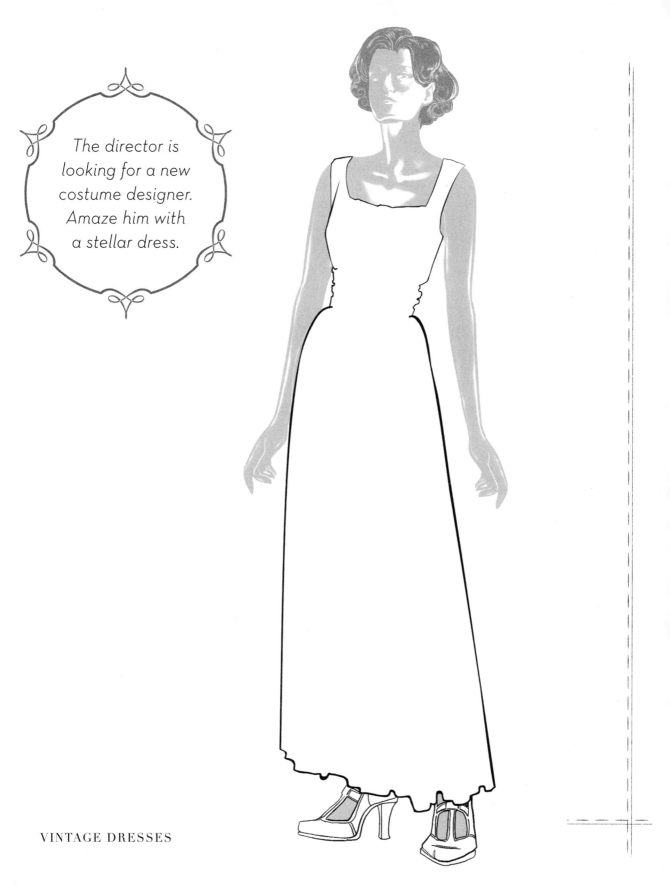

The director is looking for a new costume designer. Amaze him with a stellar dress.

VINTAGE DRESSES

"Tranquille" Cocktail Dress

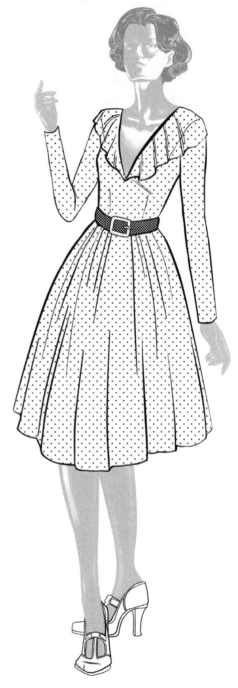

DATE & SEASON
Autumn 1945

MATERIALS
Suede and leather

INSPIRATION & STYLE
Cristóbal Balenciaga, English

Postwar Glamour

Over half a decade of war and a lifetime of limited resources later, the Second World War came to an end and haute couture reemerged from its dying embers. Cocktail dresses were desirable for their casual appearance without seeming too displaced during evening parties. This simple suede ensemble favors a frilly, low, V-shaped collar and a narrow belt at the waistline.

COLOR ME **COUTURE**

*Help celebrate the
end of the war
Create new patterns
for the party.*

VINTAGE DRESSES

"Facere" Evening Dress

DATE & SEASON

Autumn 1948

MATERIALS

Faille and rhinestones

INSPIRATION & STYLE

House of Lanvin, French

Terra Allure

An abundance of low-maintenance synthetic fabrics emerged after the war. While the quality of these new materials could not match those of natural fabrics, they held many attributes natural fibers did not. This rhinestone embedded faille evening dress shares satin's lustrous sheen without the downside of easily becoming wrinkled or dirtied.

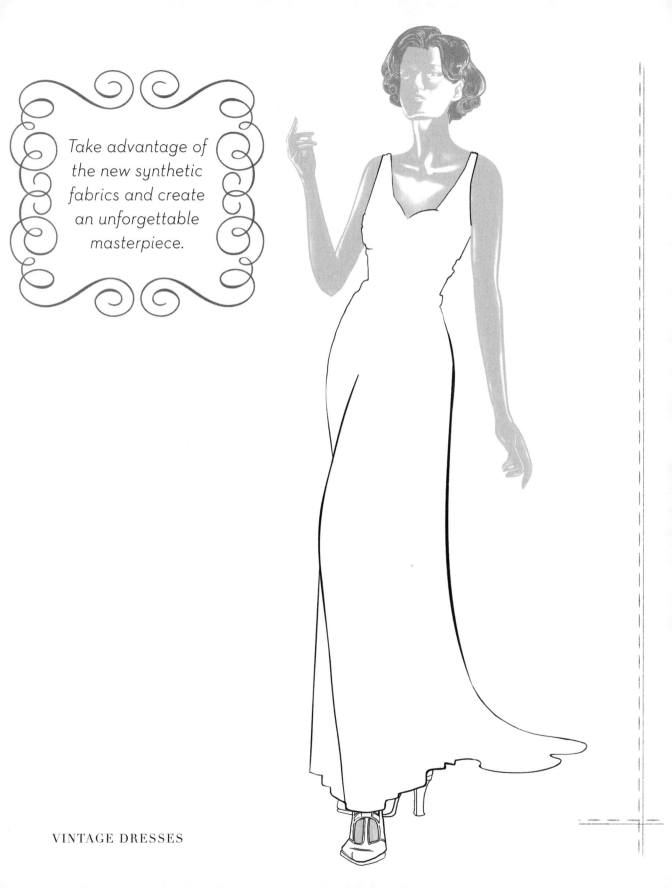

Take advantage of the new synthetic fabrics and create an unforgettable masterpiece.

VINTAGE DRESSES

"Cosmopolitan" Ensemble

DATE & SEASON

Winter 1950

MATERIAL

Wool

INSPIRATION & STYLE

Christian Dior, French

Collared Venture

With the increase in demand for office workers, more and more women joined the workforce until they married. Tailored suits were prized for their chic sophistication and practicality for the office. This fitted wool jacket gives the bodice a sharp appearance, while the pleated skirt allows the convenience of movement.

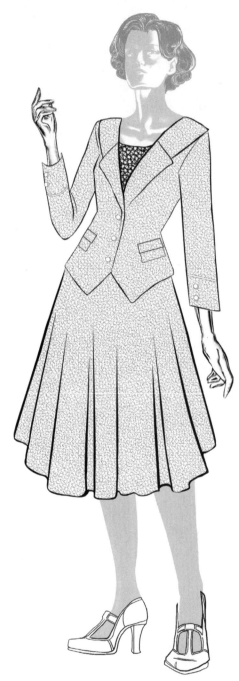

COLOR ME COUTURE

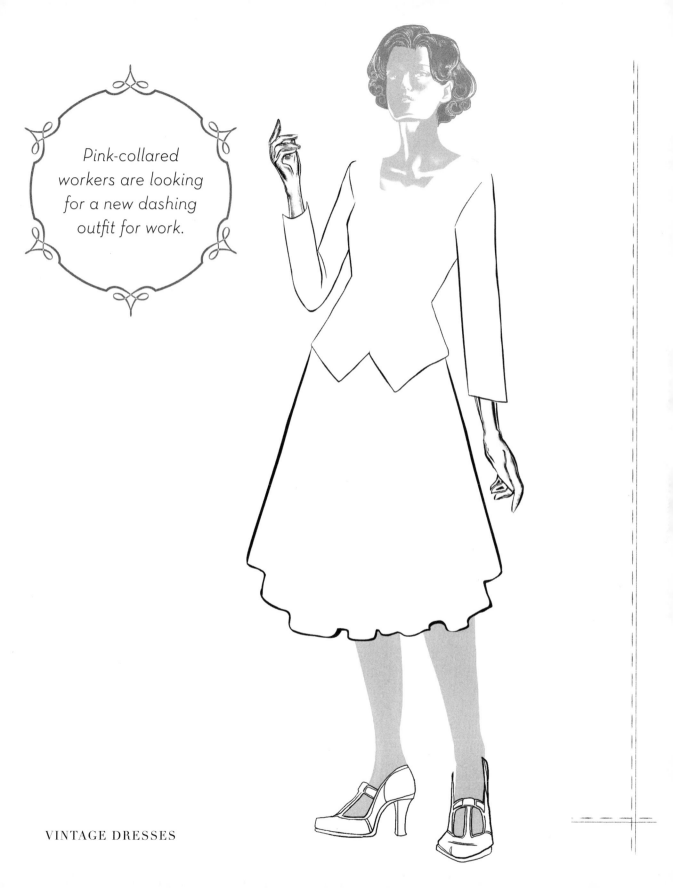

Pink-collared workers are looking for a new dashing outfit for work.

VINTAGE DRESSES

"Luxurie" Evening Dress

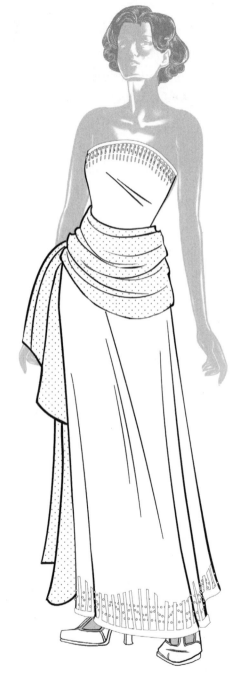

DATE & SEASON

Summer 1955

MATERIALS

Silk, satin and rhinestones

INSPIRATION & STYLE

Cristóbal Balenciaga, Italian

Illustrious Connoisseur

As fashion changed, so did art. Many social events were held at galleries with the latest abstract masterpieces on display. Socialites were often seen strolling through the gallery in this strapless silk dress studded with rhinestones at the bodice and the hemline. A draping satin sash defines the waistline with graceful fluidity.

COLOR ME **COUTURE**

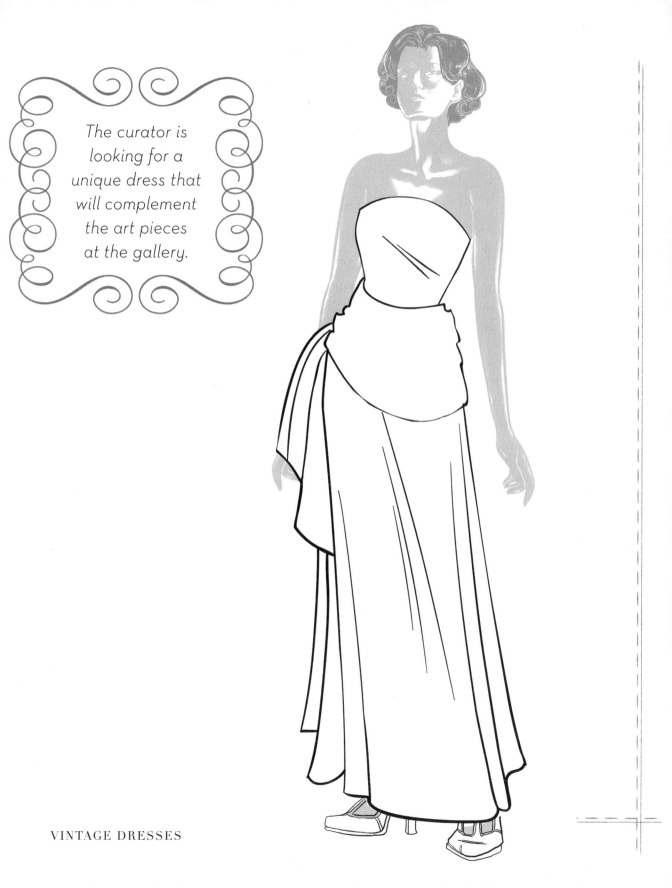

The curator is looking for a unique dress that will complement the art pieces at the gallery.

VINTAGE DRESSES

"Spatium" Cocktail Dress

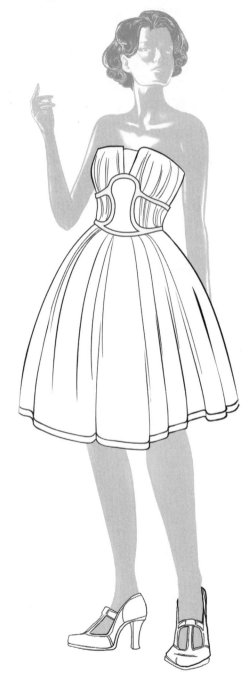

DATE & SEASON

Summer 1957

MATERIALS

Lamé and suede

INSPIRATION & STYLE

Jacques Fath, French

Sputnik Ambience

Interest in space exploration lead the avant-garde to Space Age fashion. Geometric shapes and metallic-looking fabrics were prevalent in many designs and grew more eccentric with each passing year. Metallic lamé dominates the bodice of this dress with a strong definition at the bust and waist, while the stiff angular suede skirt adheres to the geometric ideal.

COLOR ME COUTURE

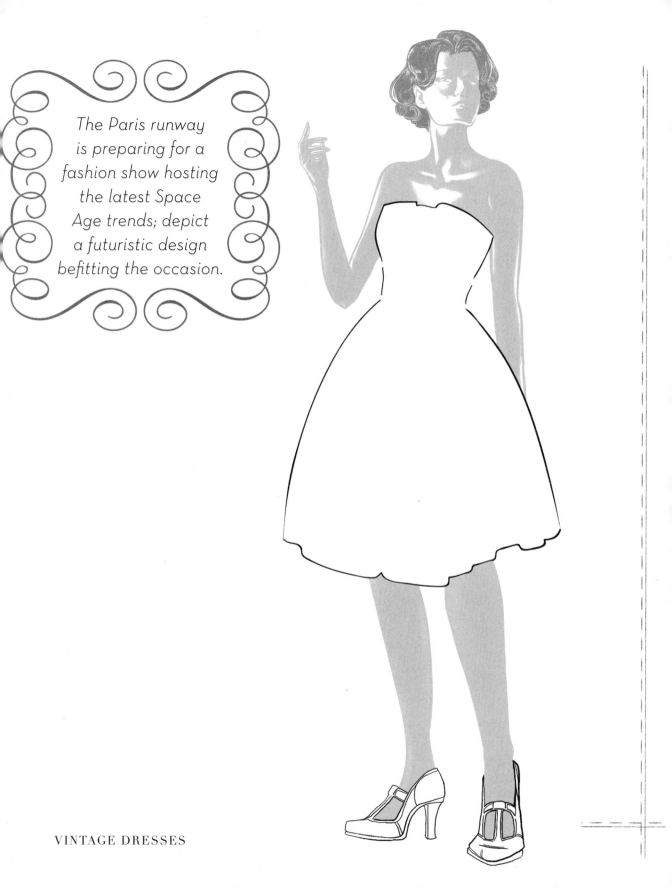

The Paris runway is preparing for a fashion show hosting the latest Space Age trends; depict a futuristic design befitting the occasion.

VINTAGE DRESSES

"Berullos" Evening Dress

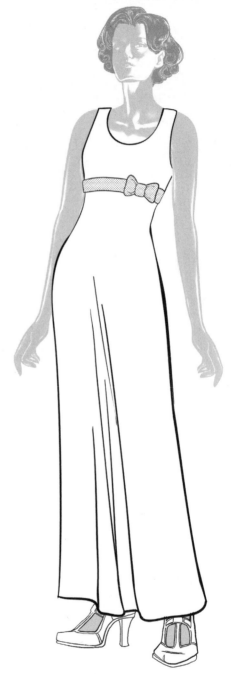

DATE & SEASON
Autumn 1960

MATERIAL
Silk

INSPIRATION & STYLE
Norman Norell, French

Minimalist Charm

Regardless the decade, a wedding is always a grand event. As a guest, it is essential to have the right outfit. This ankle-length silk dress combines charming subtlety with an air of regal refinement. Complementing the empire silhouette is a petite bow and sash beneath the bust.

COLOR ME COUTURE

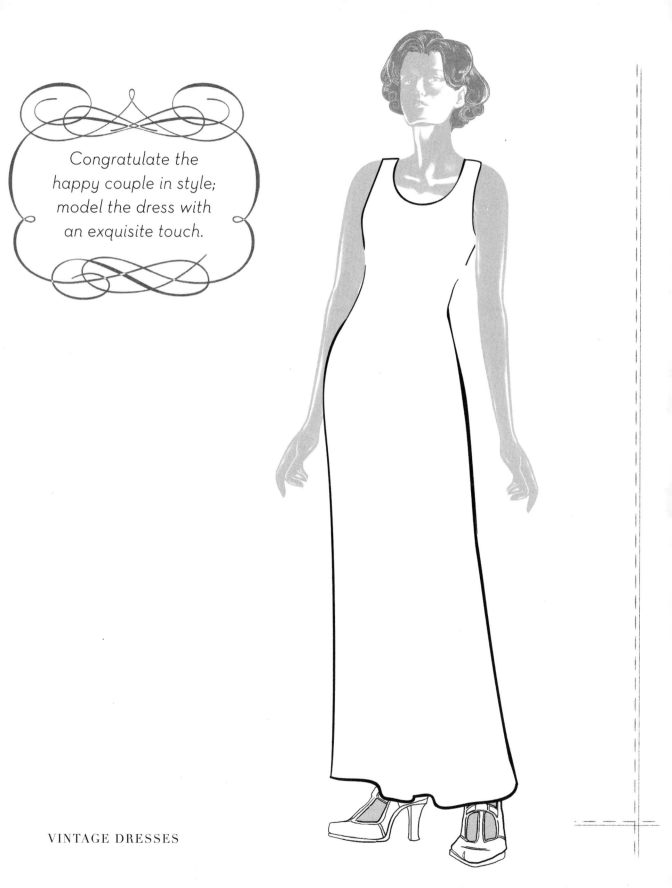

Congratulate the happy couple in style; model the dress with an exquisite touch.

VINTAGE DRESSES

Contemporary Dresses

"Aster" Evening Dress

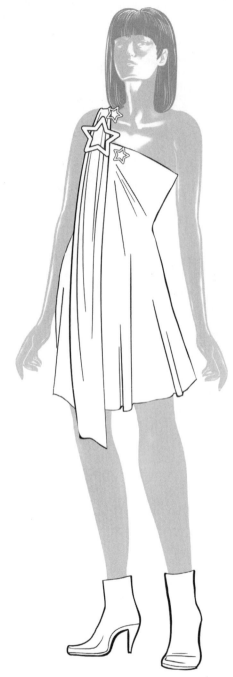

SEASON

Summer

MATERIALS

Polyester and silk

INSPIRATION & STYLE

Cristóbal Balenciaga, English

Starry Night

Contemporary haute couture is lead by popular stars in the media sporting the latest and trendiest styles. Attention is drawn to this short, asymmetrical crepe dress by its shining stars and the draping scarflike extension. The A-line silhouette gives the body a slimming appearance.

COLOR ME **COUTURE**

Up-and-coming starlets are heading to their movie premieres. Refashion the dress to catch the flashing cameras.

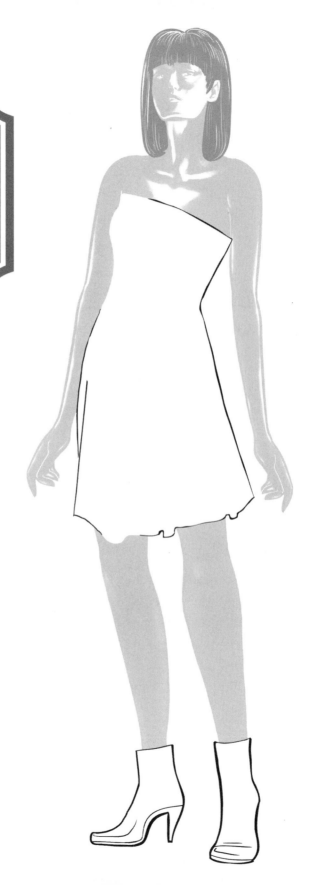

CONTEMPORARY DRESSES

"Vinea" Evening Dress

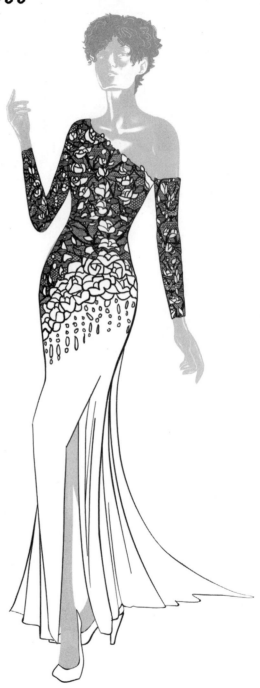

SEASON

Autumn

MATERIALS

Sheer and lace

INSPIRATION & STYLE

Alexander McQueen,
Chinese

Dangerous Ivy

Designers become bold and racy as seasons change, constantly seeking the next daring design to amaze fellow fashion enthusiasts. This ravishing sheer dress mesmerizes the eyes of many with its provocative meld of sheer and lace. A breath of sophistication is added in its fluid skirt and asymmetrical top that is reminiscent of the Chinese qipao.

COLOR ME **COUTURE**

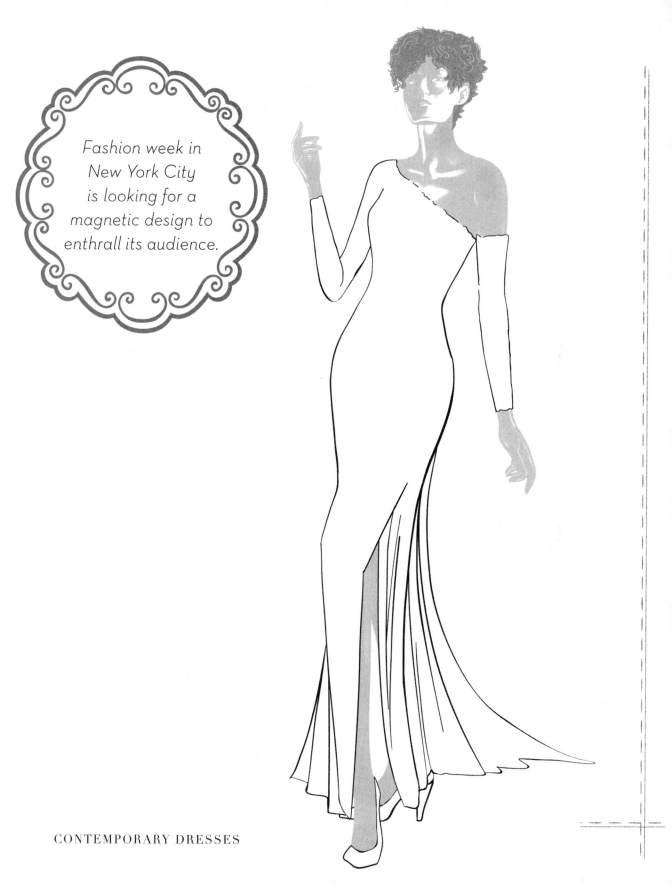

Fashion week in New York City is looking for a magnetic design to enthrall its audience.

CONTEMPORARY DRESSES

"Regalis" Empire Dress

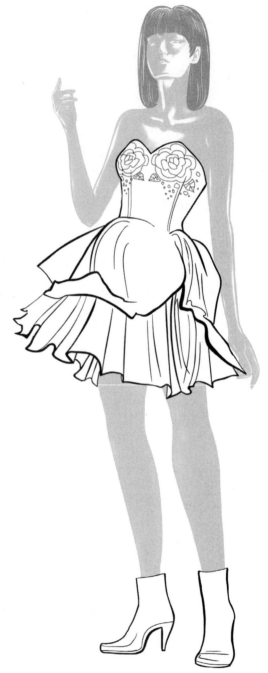

SEASON

Winter

MATERIALS

Tarlatan, organza, and embroidery

INSPIRATION & STYLE

Dilek Hanif, Italian

Rosabella

No carnival season is complete without a masquerade. Contrary to traditional masquerade gowns, this exquisite roselike dress steps into the current century with a shorter tarlatan underskirt and petal-like layers of organza. A pair of embroidered roses at the bust continues the delicate motif throughout the dress.

COLOR ME COUTURE

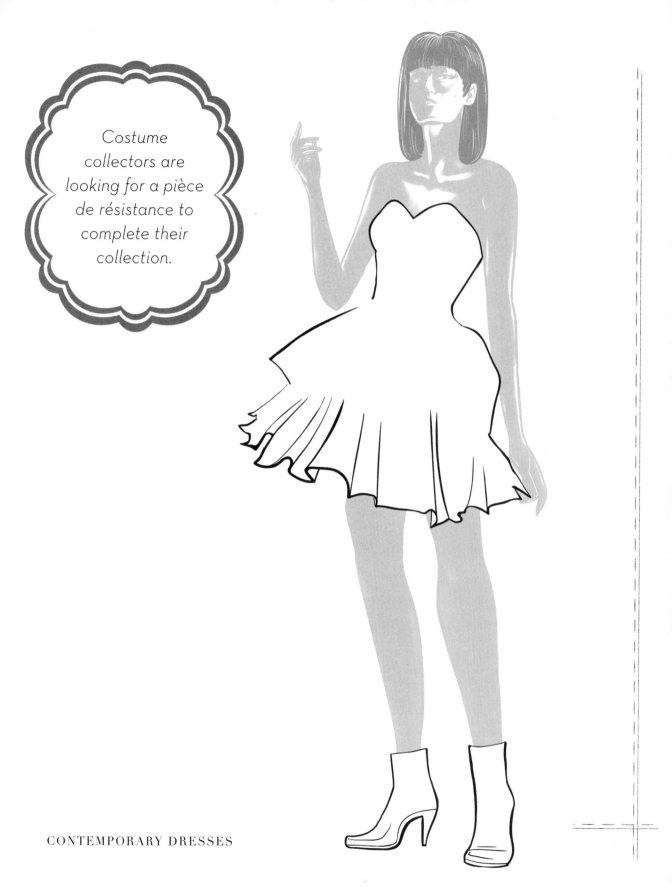

Costume collectors are looking for a pièce de résistance to complete their collection.

CONTEMPORARY DRESSES

"Krustallos" A-line Dress

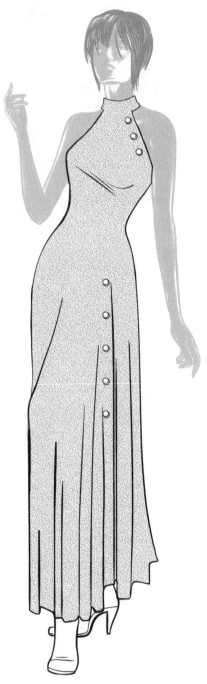

SEASON

Summer

MATERIAL

Linen

INSPIRATION & STYLE

Gilbert Adrian, English

Crystal Column

Among social events, charity balls are most highly noted for networking and working for a good cause. This cultivated high-collared dress displays an altruistic air for philanthropy with an elegant sweeping hem. The breathable linen fabric makes it suitable for summer events.

COLOR ME COUTURE

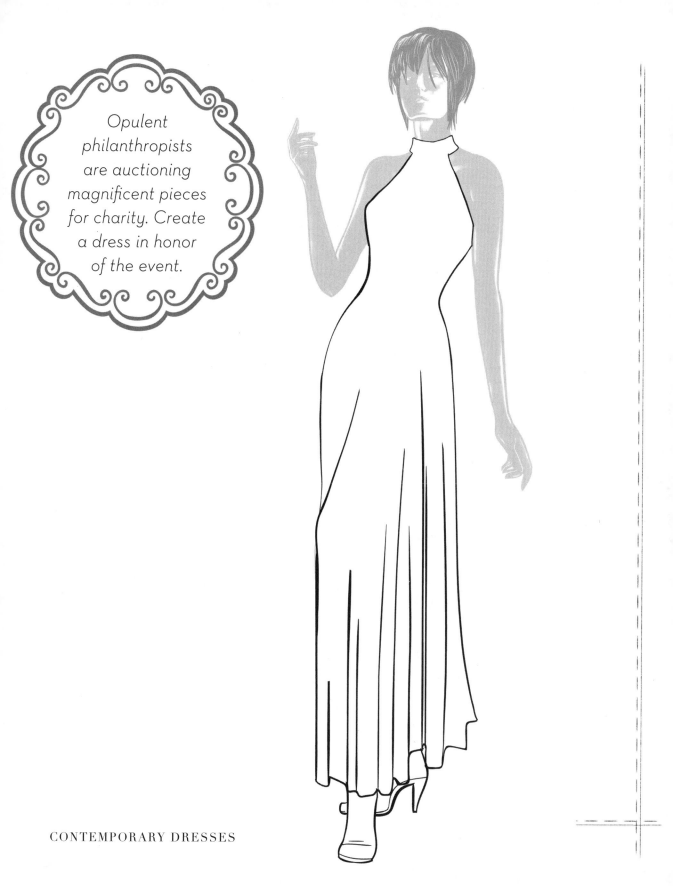

Opulent philanthropists are auctioning magnificent pieces for charity. Create a dress in honor of the event.

CONTEMPORARY DRESSES

"Classique" Cocktail Dress

SEASPON

Autumn

MATERIALS

Silk, satin, and Chantilly lace

INSPIRATION & STYLE

House of Chanel, French

Little Onyx

Essential to every woman's wardrobe is a little black dress. Whether for work or a cocktail party, this strapless, flouncy silk dress is suitable for any occasion. The short Chantilly lace jacket and low satin sash give a polished appearance while still casual enough for a relaxed evening out with friends.

COLOR ME COUTURE

Time is precious for the average businesswoman; create a dress that's appropriate for both work and play.

CONTEMPORARY DRESSES

"Cīvis" Sheath Dress

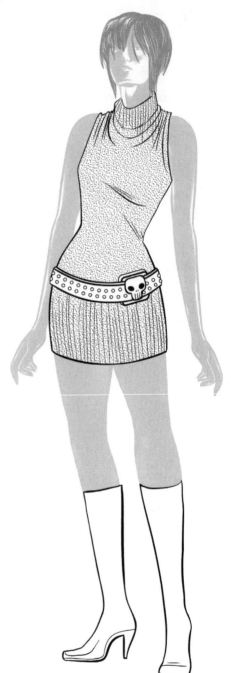

SEASON

Autumn

MATERIALS

Cashmere, studded belt, and skull clasp

INSPIRATION & STYLE

Chanel, French

Malar Suture

Whether going to a luncheon or strolling the streets of Fifth Avenue in New York City, this classy cashmere turtleneck skirt is the ideal for the autumn season with its light fabric and soft texture. Enhancing the ribbed hem of the formfitting skirt is a studded belt with a skull clasp.

Patrons on Fifth Avenue are looking for a new dress to stand out in the city.

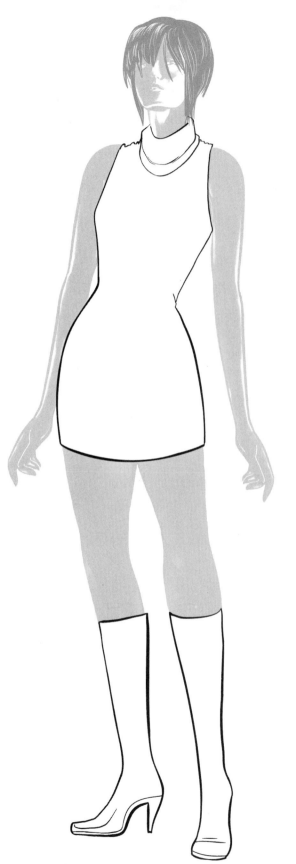

CONTEMPORARY DRESSES

"Juxtaposition" Dress

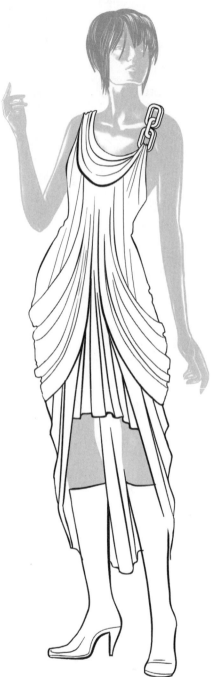

SEASON

Summer

MATERIALS

Chiffon, silk, and chains

INSPIRATION & STYLE

Alexander Wang, Greek

Time Compression

Fashion is constantly changing, drawing ideas from the near present and the far past. This eccentric dress is an amalgam of a Grecian chiton and modern flair. The single-strap chiffon dress is held up with a thick chain link. Its hem opens up to an asymmetrical silk underskirt with a short front and a train-like back.

COLOR ME **COUTURE**

Flabbergast the public by integrating designs from different decades.

CONTEMPORARY DRESSES

"Rogue" Leather Dress

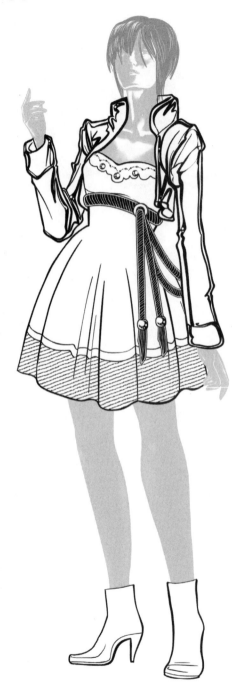

SEASON

Summer

MATERIALS

Denim, leather, stones, and rope

INSPIRATION & STYLE

Dolce & Gabbana, American

Rockabilly Stride

Reminiscent of the rambunctious 1950s teenagers, this snazzy halter and denim skirt accompanied by a cropped leather jacket is excellent for motorcycle-chic enthusiasts. Adorning the bust are studded stones and a lengthy rope belt with tassels. The bottom hem is decorated with a similar rope hem and a petite bow.

COLOR ME **COUTURE**

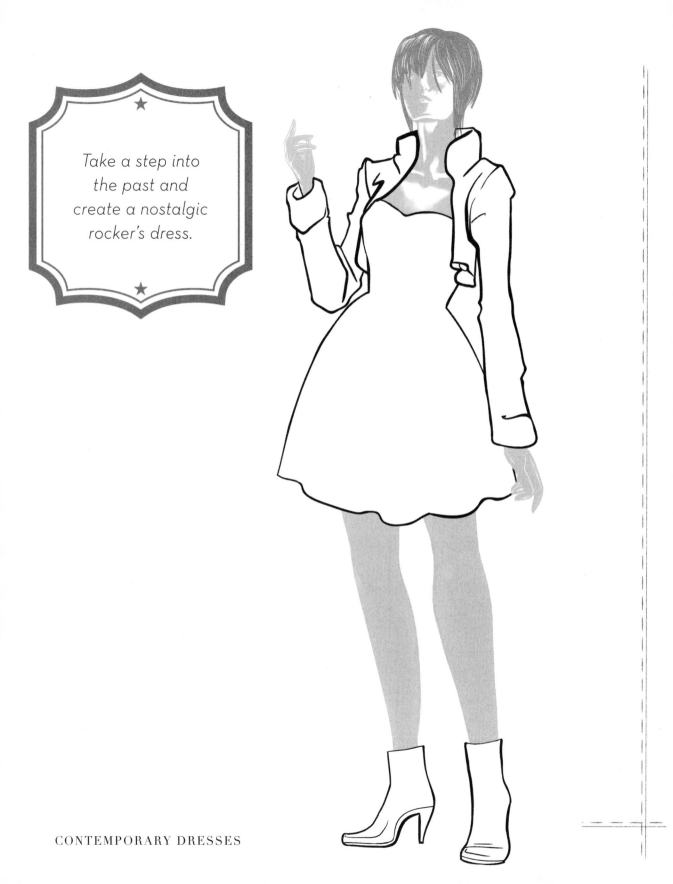

Take a step into
the past and
create a nostalgic
rocker's dress.

CONTEMPORARY DRESSES

"Cyberpunk" Ensemble

SEASON

Autumn

MATERIALS

Leather, fine-knit wool, elastic belt, and metal clasp

INSPIRATION & STYLE

Donatella Versace, English

Neopolitan

Dipping into science fiction, fashion returns with a darker look into futuristic clothing. The high-collar dress gives off a sense of mystery paired with a thick, clasped belt. The edgy trench sweater coat with its fringed hem adds a dramatic flair when walking on a windy day.

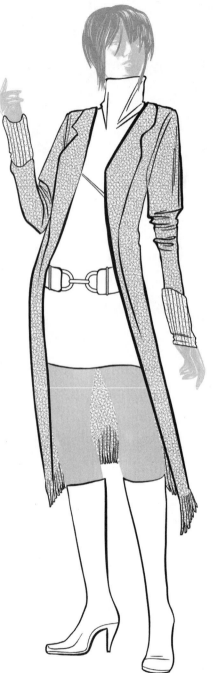

COLOR ME COUTURE

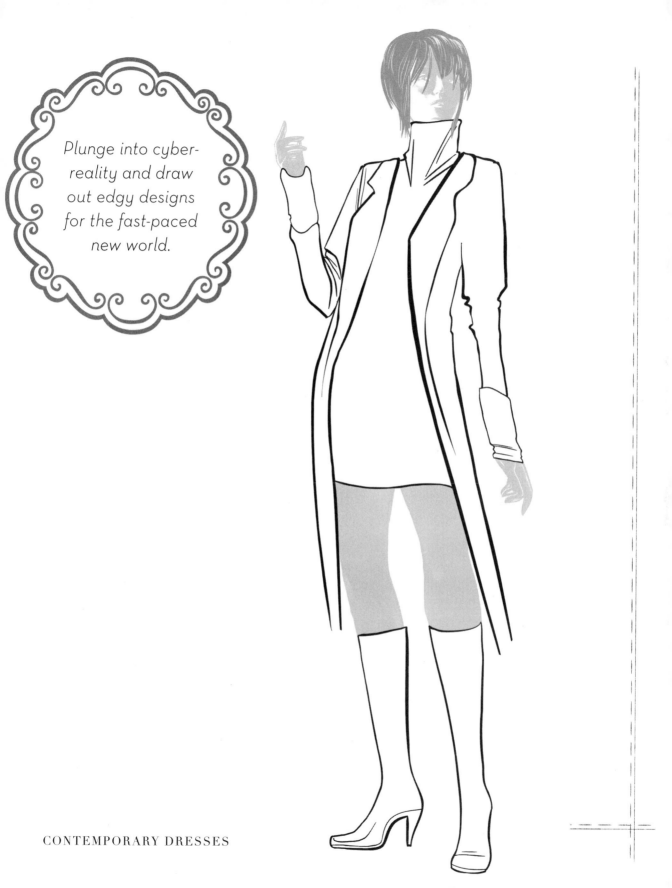

Plunge into cyber-reality and draw out edgy designs for the fast-paced new world.

CONTEMPORARY DRESSES

"Romdies" Dress

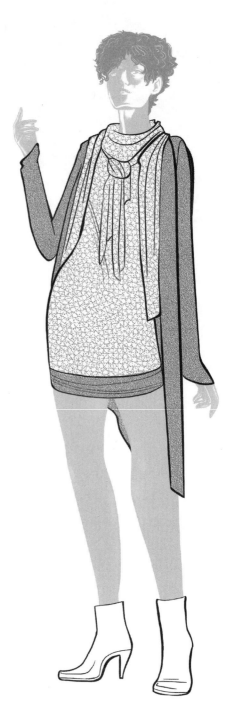

SEASON

Autumn

MATERIALS

Linen and silk

INSPIRATION & STYLE

Moschino, Italian

Versailles Romance

Designed with a scarf as a part of the dress, this stylish linen-silk ensemble can be tied in a different knot with each wear, making it versatile for multiple occasions. The asymmetrical cardigan enhances the draping appearance given by the scarf while keeping the chill away.

Hopeful romantics are dreaming of finding their one true match. Create a dress perfect for their first meeting.

CONTEMPORARY DRESSES

"Deathpunk" Ensemble

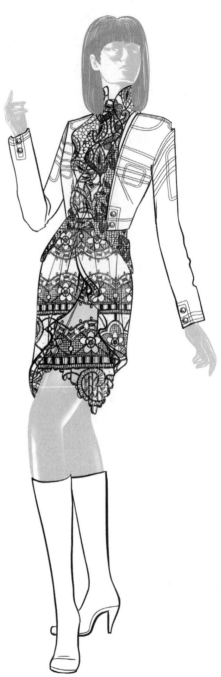

SEASON

Winter

MATERIALS

Leather, lace, zippers, and belts

INSPIRATION & STYLING

Moschino, English

Exodus Song

Stepping out of the norm, this eccentric dress combines a frilly lace top and a layered leather miniskirt with an extended laced underskirt, adding a dangerous air to an innocent appearance. The rugged leather jacket adorned with a number of zippers and belts on its breast and sleeves gives it an eclectic feel.

COLOR ME COUTURE

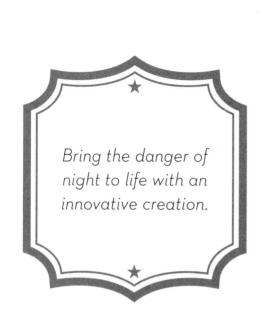

Bring the danger of night to life with an innovative creation.

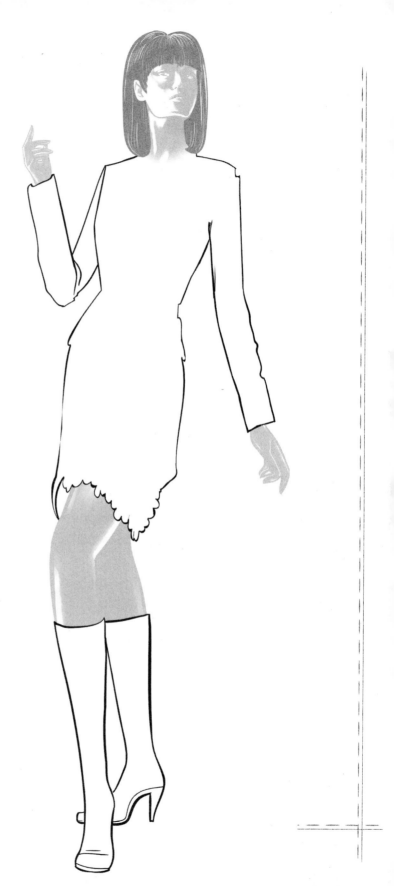

CONTEMPORARY DRESSES

"Esclave" Dress

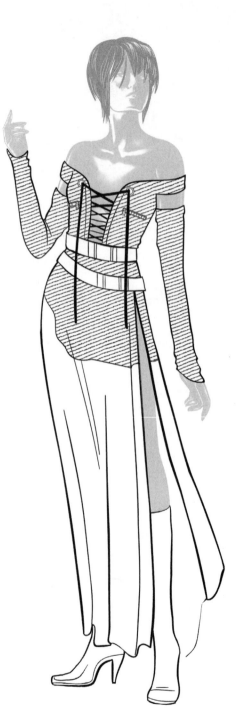

SEASON
Autumn

MATERIALS
Knitted fabric, plaid, belts, and zippers

INSPIRATION & STYLE
Roberto Cavalli, English

Archaic Allure

Heavy with belts and zippers, this bold dress captivate audiences with its bare shoulders and choker collar. The ribbed-knitted top and long plaid skirt merges midway with the slit at the bottom, masterfully integrating a seductive allure to the dress.

COLOR ME COUTURE

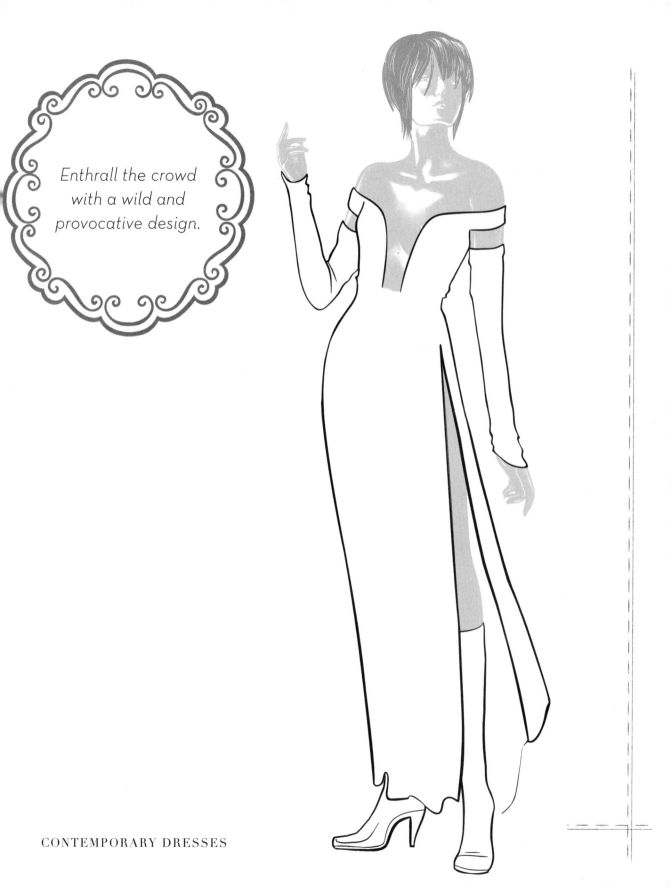

Enthrall the crowd with a wild and provocative design.

CONTEMPORARY DRESSES

"Sucré" Waffle Dress

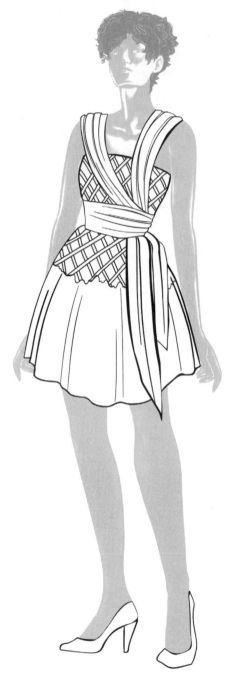

SEASON

Spring

MATERIALS

Waffle-weave cotton

INSPIRATION & STYLE

House of Paquin, French

Tea à la Mode

Afternoon tea never goes out of style, even after a century. This whimsical spring dress is perfect for the occasion with its elegantly tied sash and poppy flower-like skirt. The resemblance to an actual waffle only serves to wet the appetite.

The glitterati are looking for a cute outfit for weekend brunch. Create a dress suitable for a day of shopping and fun.

CONTEMPORARY DRESSES

"Ciel" Weave Dress

SEASON

Summer

MATERIALS

Satin, silk, sequin, and bows

INSPIRATION & STYLE

Alexander Wang, French

Midnight Wine

Sparkling like the night sky, the sequin bust of this softly folded dress is accentuated by satin sashes weaving through the fluttering silk dress with a line of bows increasing in size with each weave. This lovely dress is complemented with a matching satin sash choker.

COLOR ME COUTURE

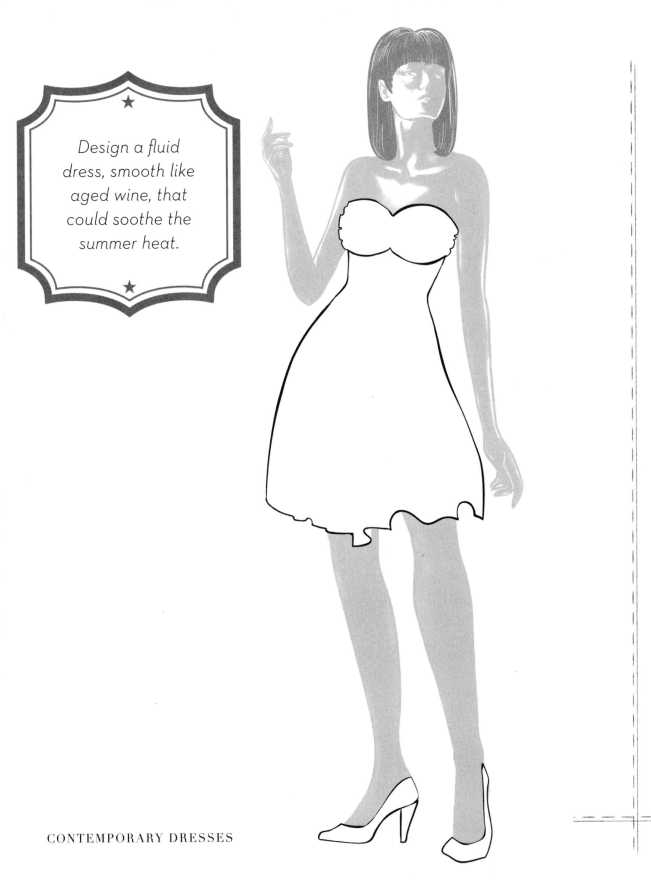

Design a fluid
dress, smooth like
aged wine, that
could soothe the
summer heat.

CONTEMPORARY DRESSES

"Pagus" Corset Dress

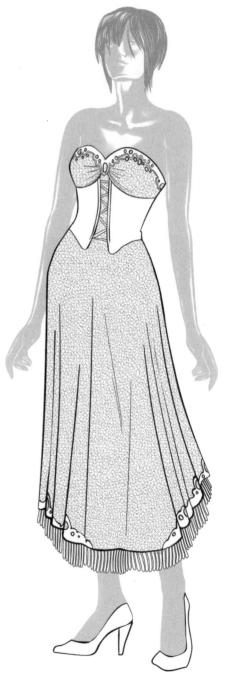

SEASON

Autumn

MATERIALS

Silk, embroideries, and lace

INSPIRATION & STYLE

Dolce & Gabbana, English

Western Skies

With how predominate corsets were in the previous century, it is no wonder it made a reappearance in various social functions. This remarkable dress uses the corset to emphasize the bust while the lacing serves as a decorative piece. This silk A-line dress is enriched with simple embroideries and a featherlike hemming.

COLOR ME COUTURE

With curvaceous bodies returning in popularity, stars and socialites alike are looking for a stylish dress for their parties.

CONTEMPORARY DRESSES

Assorted Fashion Garments

"Tegere" Evening Cape

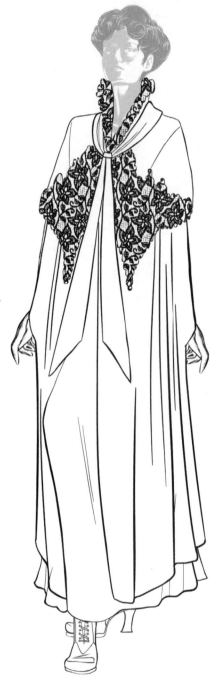

DATE & SEASON

Autumn 1880

MATERIALS

Velvet and lace

INSPIRATION & STYLE

House of Worth, French

Traverse Companion

It hardly matters how beautiful a dress or gown is if it is ruined during travel. This lavish double-tiered velvet cape does well to protect delicate dresses against the elements to and from home while still retaining a debonair presence. The lengthy scarf boldly draws attention to the fine lace embroidered on the shorter tier.

COLOR ME COUTURE

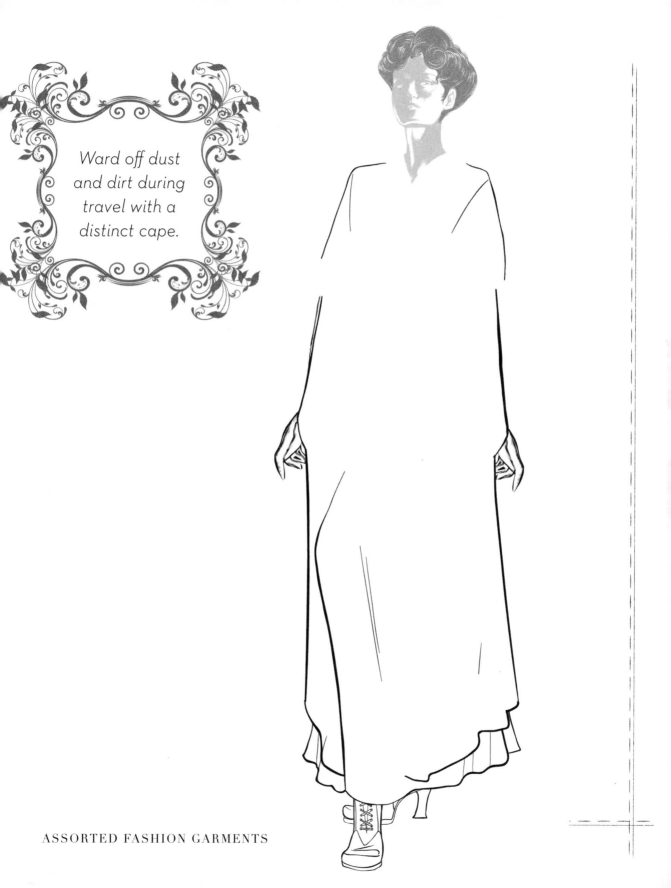

Ward off dust and dirt during travel with a distinct cape.

ASSORTED FASHION GARMENTS

"Pelegrin" Opera Cape

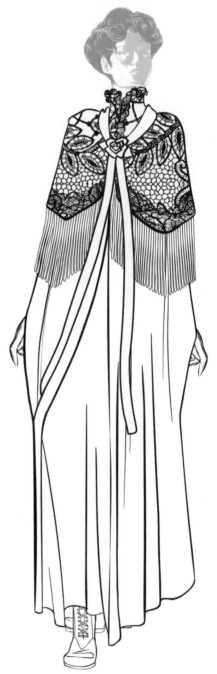

DATE & SEASON

Winter 1890

MATERIALS

Cashmere, crochet, and tassels

INSPIRATION & STYLE

House of Worth, Italian

Socialite Grace

An evening out at the opera house is hardly appropriate without adding a dramatic flair to one's wardrobe. This extravagant high-collared cashmere cape is layered with a short crochet mantle adorned with fringe and a lengthy tassel. A gentle sweep and billowing of the cape is enough to feel a part of the performance.

COLOR ME COUTURE

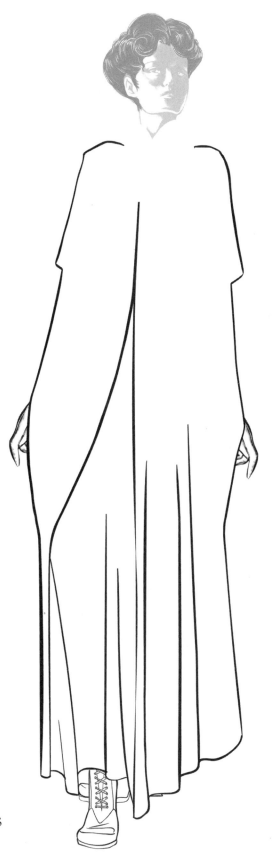

The prima donna is refusing to venture through the weather to the theatre. Fashion a cape that will appeal to her tastes.

ASSORTED FASHION GARMENTS

"Onare" Evening Cloak

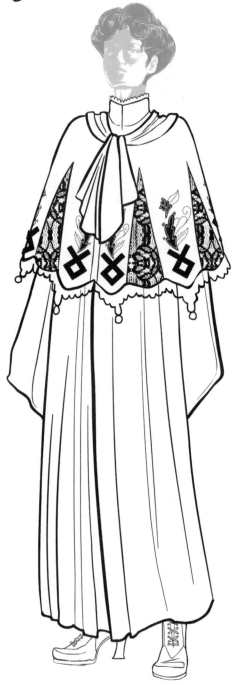

DATE & SEASON
Winter 1895

MATERIALS
Suede, ecru silk, and brooch

INSPIRATION & STYLE
Emile Pingat, French

Winter's Eve

Enjoy the beauty of winter's first snowfall in cozy comfort with this suede and ecru silk cloak. This classy ensemble is decorated with a frilled hem and ornate ruffled top. Tied loosely around the neck is a simple ascot wrap.

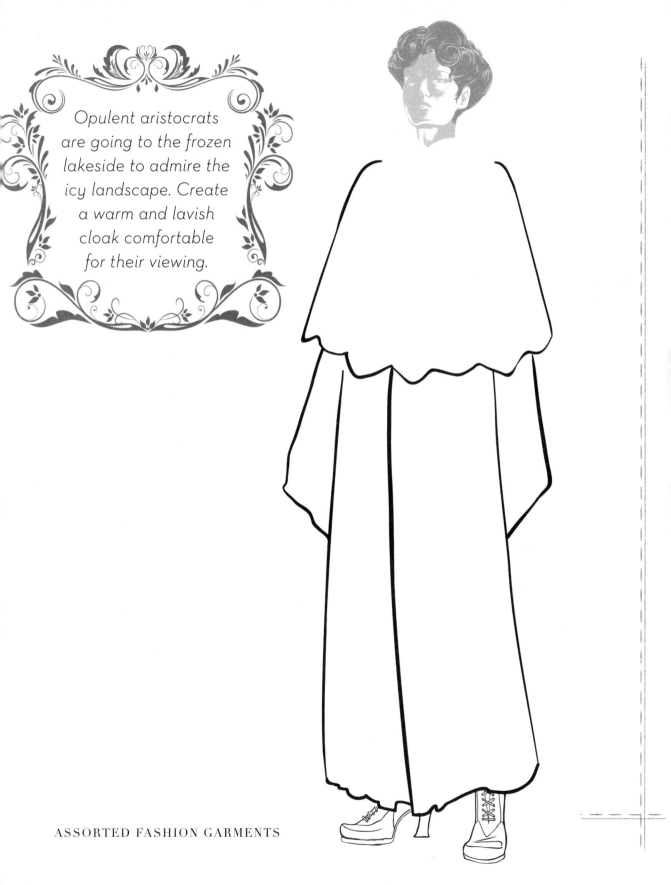

Opulent aristocrats are going to the frozen lakeside to admire the icy landscape. Create a warm and lavish cloak comfortable for their viewing.

ASSORTED FASHION GARMENTS

"Leisir" Evening Mantle

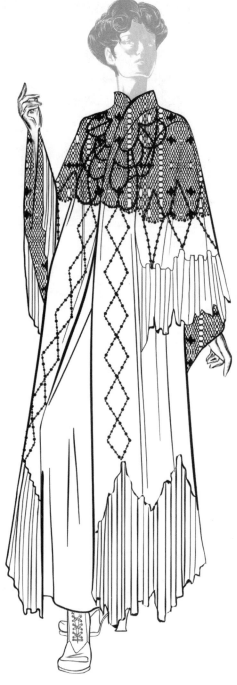

DATE & SEASON
Spring 1899

MATERIALS
Satin and embroidered beads

INSPIRATION & STYLE
Emile Pingat, French

Promenade

Embroidered beads dominate this mantle with intricate designs twisting and dancing across the satin surface. The beaded fringe sashays melodically alongside each movement, giving a unique and hypnotic appearance to the wearer. This delectable mantle is excellent for a cool evening stroll.

COLOR ME COUTURE

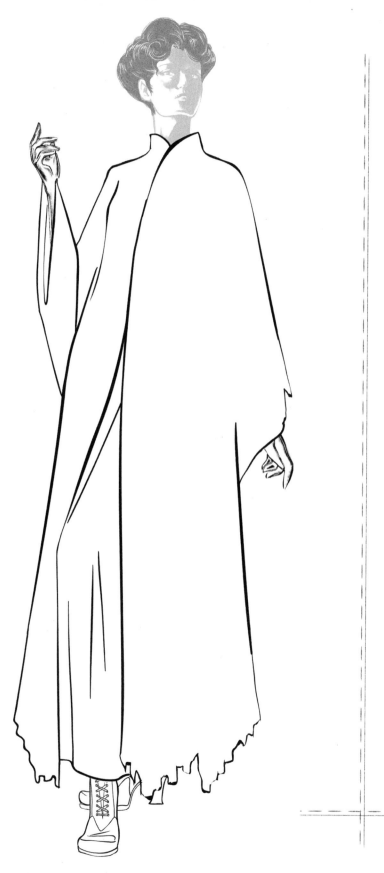

ASSORTED FASHION GARMENTS

"Forrer" Fur Coat

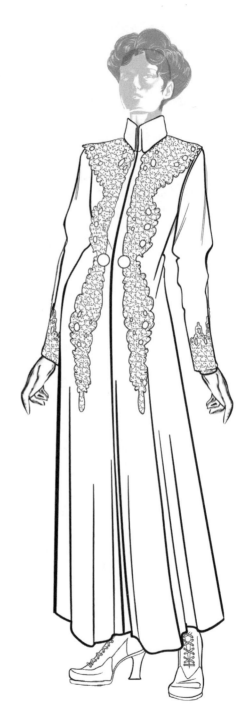

DATE & SEASON
Winter 1919

MATERIALS
Fur and wool

INSPIRATION & STYLE
Paul Poiret, Russian

Decadent Traveler

Tunics and fur were at the height of popularity and were often paired for coats that were worn into the city or for travel. This high-collared wool coat is defined lightly at the waistline, accentuated with an overlapping layer of fur on the shoulders and trailing down the front.

COLOR ME COUTURE

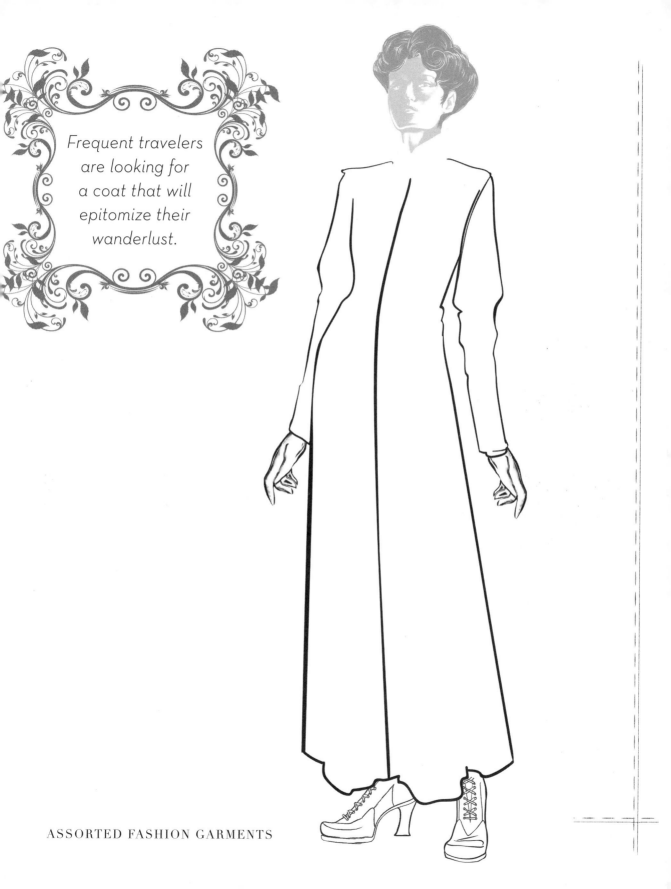

Frequent travelers are looking for a coat that will epitomize their wanderlust.

ASSORTED FASHION GARMENTS

"Solidus" Trench Coat

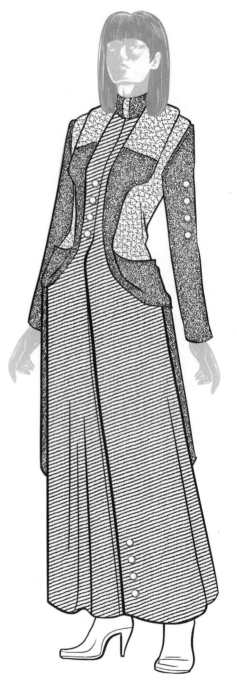

SEASON

Autumn

MATERIAL

Wool gabardine

INSPIRATION & STYLE

Alexander McQueen,
English

Asymmetrical Madness

Most notably worn by soldiers during the World Wars, trench coats remained in fashion long after their original objective had been seen. This sleek wool gabardine coat is both stylish with its asymmetrical designs and practical with its insulating and water-repelling fabric.

COLOR ME COUTURE

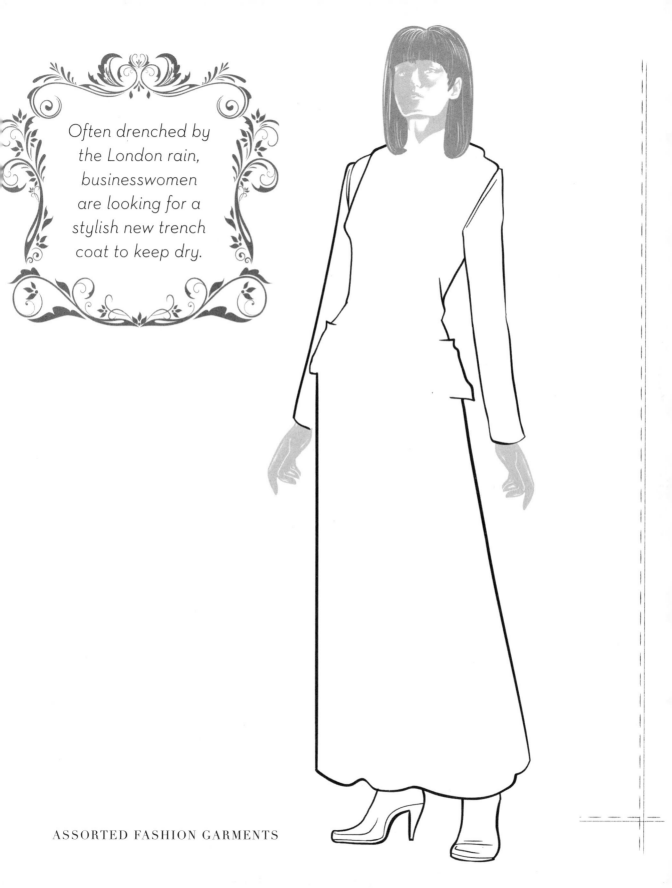

Often drenched by the London rain, businesswomen are looking for a stylish new trench coat to keep dry.

ASSORTED FASHION GARMENTS

"Navis" Peacoat

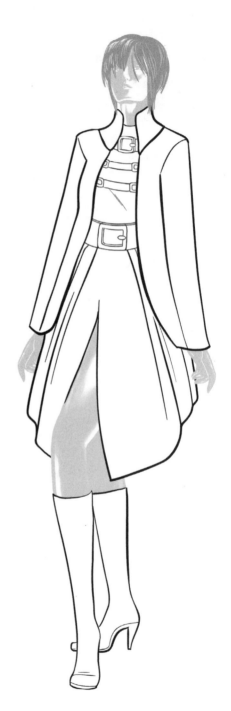

MATERIALS

Wool, rings, buttons, and buckled belt

INSPIRATION & STYLE

Donatella Versace, Russian

Serene Glacier

Much like the trench coat, the peacoat is another military garment restyled and adopted into fashion. This fetching wool coat stands out with its skirtlike design and double-breast buttons. The high collar is clasped together by a decorative metal ring, and defining the waist is a thick buckled belt.

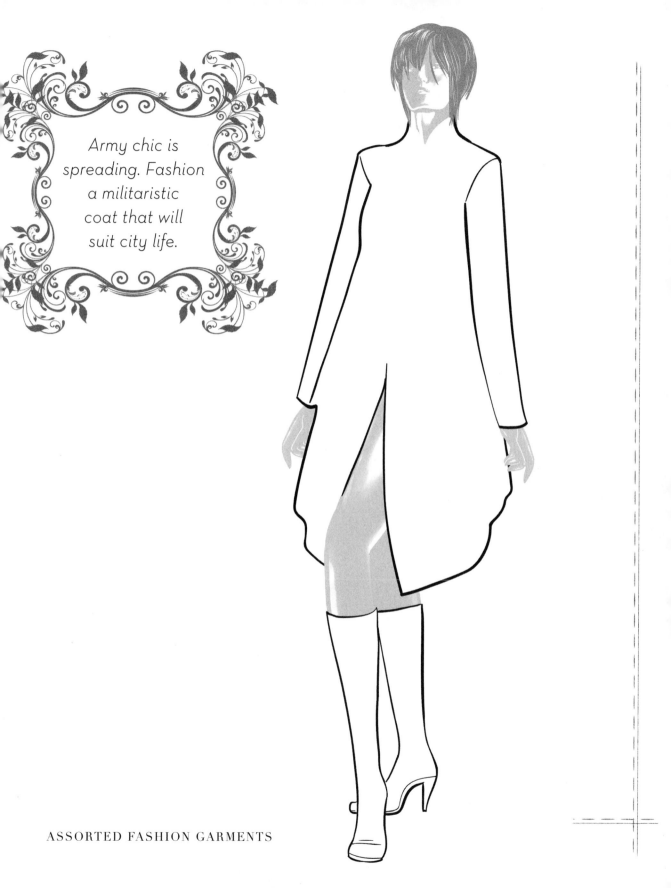

Army chic is spreading. Fashion a militaristic coat that will suit city life.

ASSORTED FASHION GARMENTS

"Maius" French Nightgown

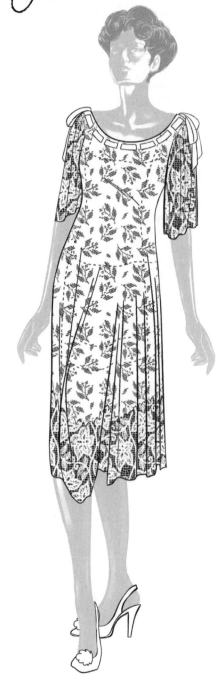

DATE & SEASON

Spring 1920

MATERIAL

Cotton

INSPIRATION & STYLE

Callot Soeurs, French

May Flowers

After a long day, slipping into this comfortable cotton negligee is more than desirable. Loose and soft to the touch, this flowery decollate nightgown is ideal for lounging in the comfort of one's home while relaxing with a book by the window.

COLOR ME **COUTURE**

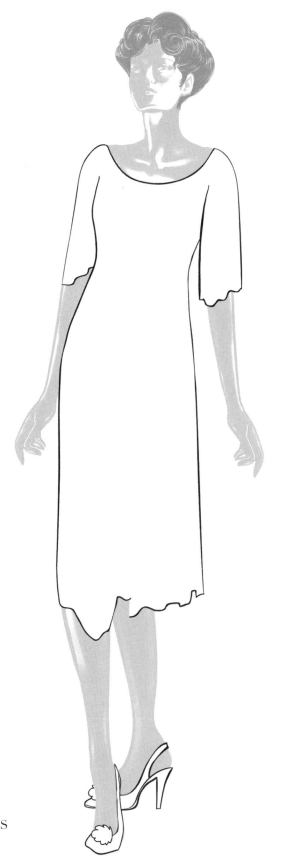

Submerged in a book, avid readers are in need of comfortable nightwear that will not distract them from their adventures.

ASSORTED FASHION GARMENTS

"Entretenir" Silken Robes

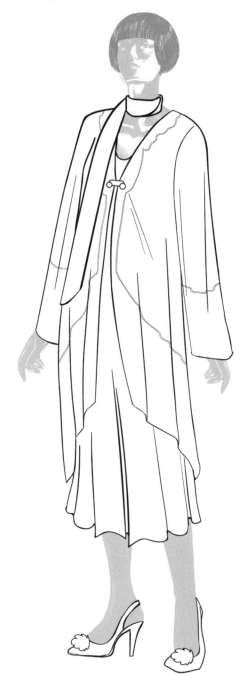

DATE & SEASON

Spring 1921

MATERIAL

Silk

INSPIRATION & STYLE

Paul Poiret, French

Repose Luxury

Visiting guests could come at any time, and occasionally in the evening well past dinner. This modest silk gown and robe makes it convenient to entertain guests without the worry of indecency and easy to retire to bed in a short notice after the guests depart. The contrasting silk scarf adds an air of sophistication.

COLOR ME COUTURE

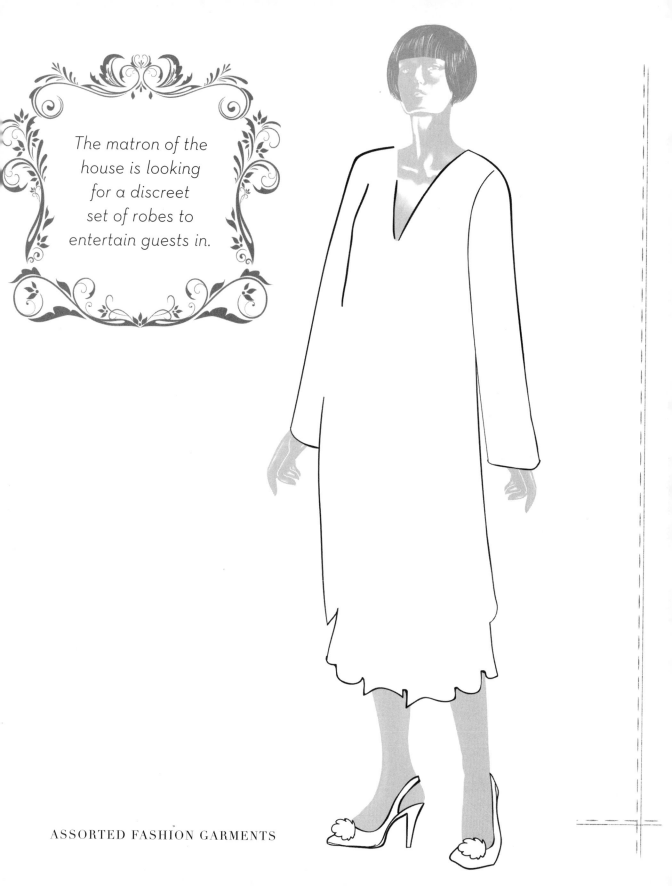

The matron of the house is looking for a discreet set of robes to entertain guests in.

ASSORTED FASHION GARMENTS

"Reverie" French Pajamas

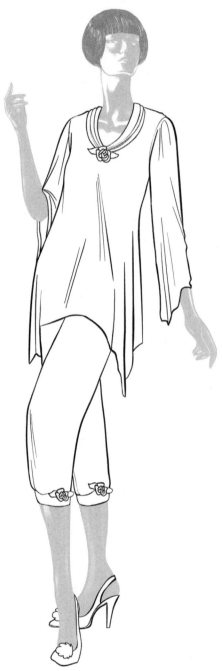

DATE & SEASON
Summer 1926

MATERIAL
Silk

INSPIRATION & STYLE
Coco Chanel, French

Dreams of Paris

Summer eves could be unbearably warm, and this fluid set of silk pajamas was marvelous to ward off the heat. The draping sleeves brush away the heat with each delicate sweep, cooling the body throughout the evening. Three dainty flowers peek out from the collar and the bottom hem.

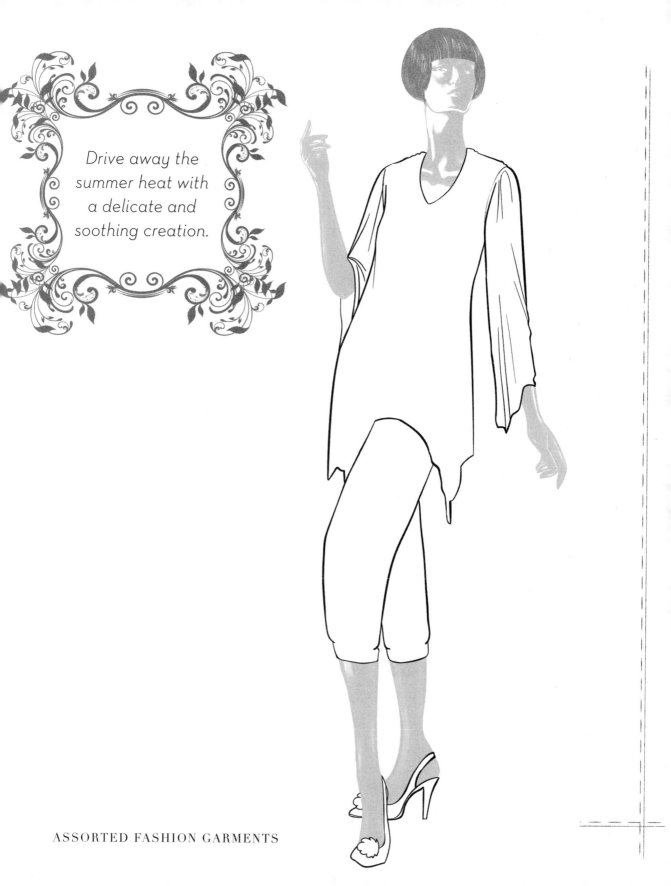

Drive away the summer heat with a delicate and soothing creation.

ASSORTED FASHION GARMENTS

"Eros" French Corset

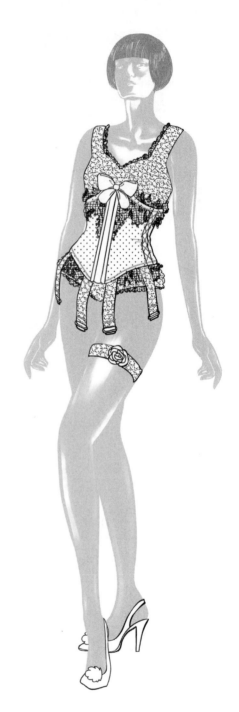

DATE & SEASON

Summer 1930

MATERIAL

Satin

INSPIRATION & STYLE

Callot Soeurs, French

Waiting for My Beloved

While the corset was mostly discarded in favor of more relaxed and comfortable undergarments like camisoles and bloomers, this lacy four-piece satin set returned in popularity through the silver screen. Love stuck heroines wore this racy undergarment while waiting for their beloveds.

COLOR ME COUTURE

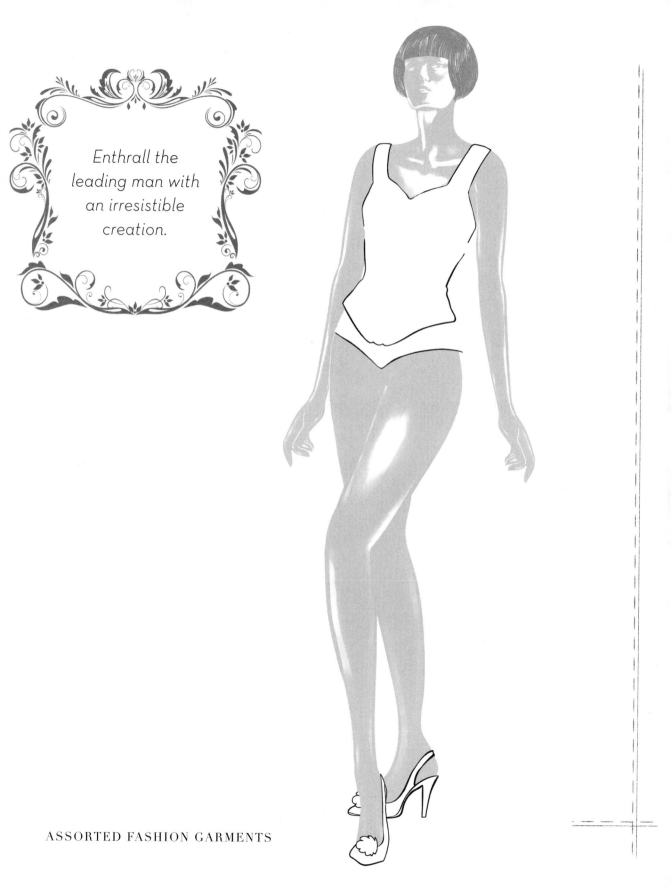

Enthrall the leading man with an irresistible creation.

ASSORTED FASHION GARMENTS

"Candere" French Lingerie

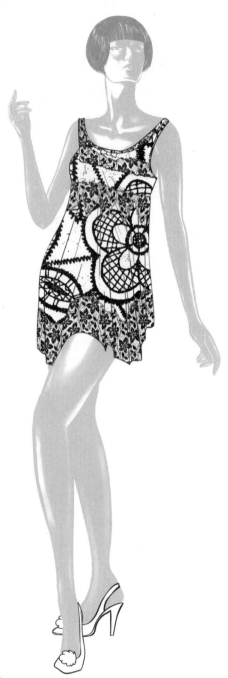

DATE & SEASON

Summer 1931

MATERIAL

Silk

INSPIRATION & STYLE

Coco Chanel, French

Dreams by Candlelight

Though negligee are not supposed to be seen by others, who can fault a girl for wearing something as comfortable and luxurious as this chemise? Short and loose fitting, the garment hangs off the shoulders and flows freely down the body. This silken piece is desirable in bed and for lounging at home.

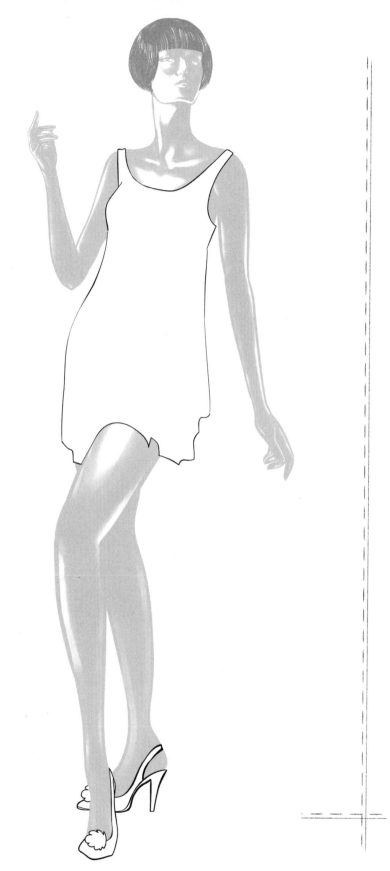

Ease into the dreamscape with a delicate blend of layers and patterns.

ASSORTED FASHION GARMENTS

"Amore" Silk Slip

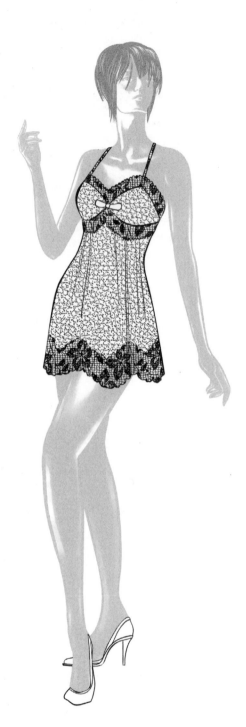

SEASON

Summer

MATERIALS

Silk and lace

INSPIRATION & STYLE

Daphne Hughes, English

Amber Romance

Soft and feminine with a hint of flirty charm in its lacy hem, this baby-doll nightgown cups the bust with matching lace and a delicate bow. Hung on thin spaghetti straps, the mid-thigh gown gives a wistful boudoir appearance.

COLOR ME COUTURE

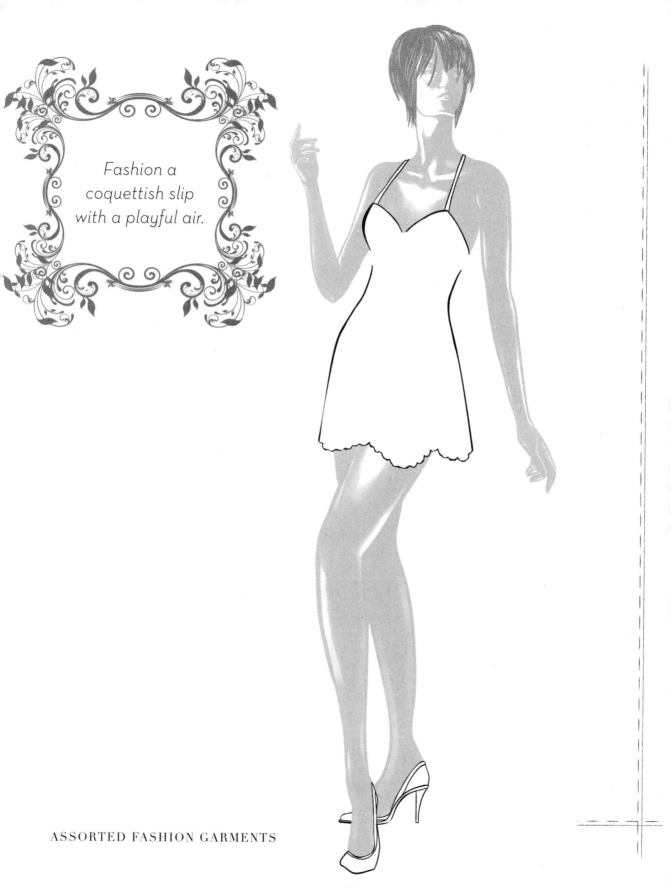

Fashion a coquettish slip with a playful air.

ASSORTED FASHION GARMENTS

"Ducere" Satin Nightgown

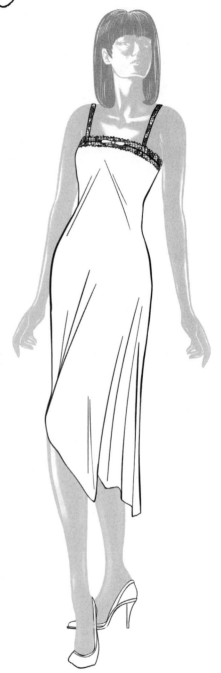

SEAS

Autumn

MATERIAL

Satin

INSPIRATION & STYLE

Christian Dior, English

Pure Seduction

Smooth and fluid, this sultry satin nightgown seduces the night with its asymmetrical hem draping against bare knees. A frilled trim and bow adorn the hem of the bust, adding a delightful touch to the gown.

COLOR ME COUTURE

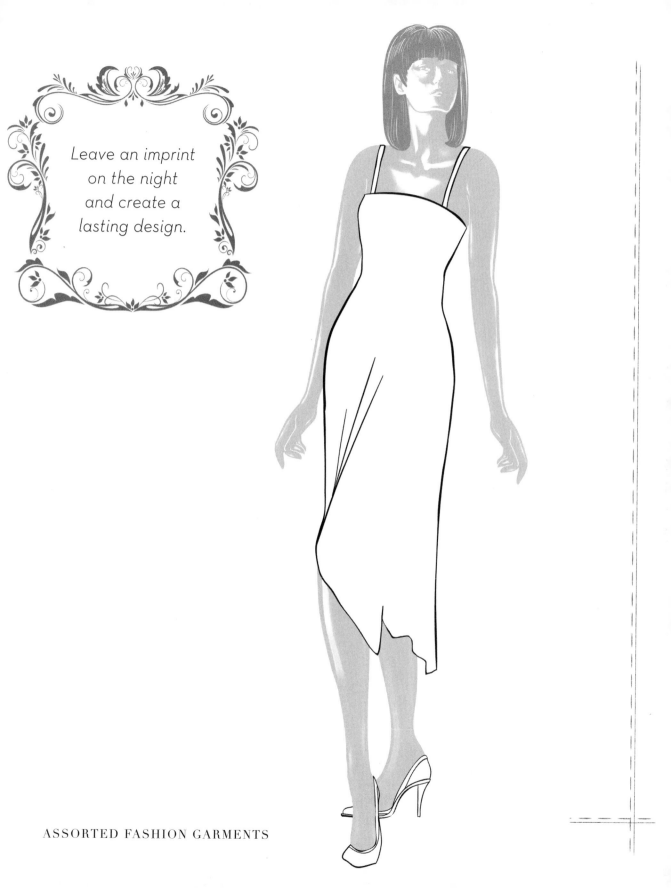

Leave an imprint on the night and create a lasting design.

ASSORTED FASHION GARMENTS

"Kerasos" Charming Pajamas

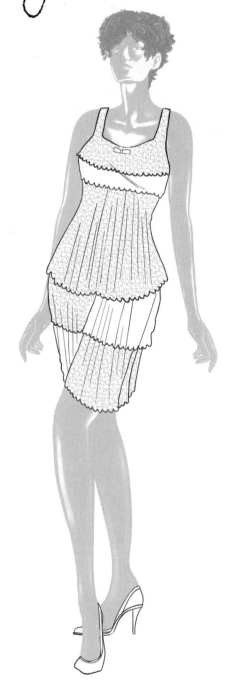

SEASON

Summer

MATERIAL

Cotton

INSPIRATION & STYLE

Christian Dior, French

Ruffles

Sweet and loveable, this ruffled cotton pajama resembles the soft petals of cherry blossoms in full bloom with its frilly layers. This darling piece captures the air of innocence and youthful femininity.

COLOR ME COUTURE

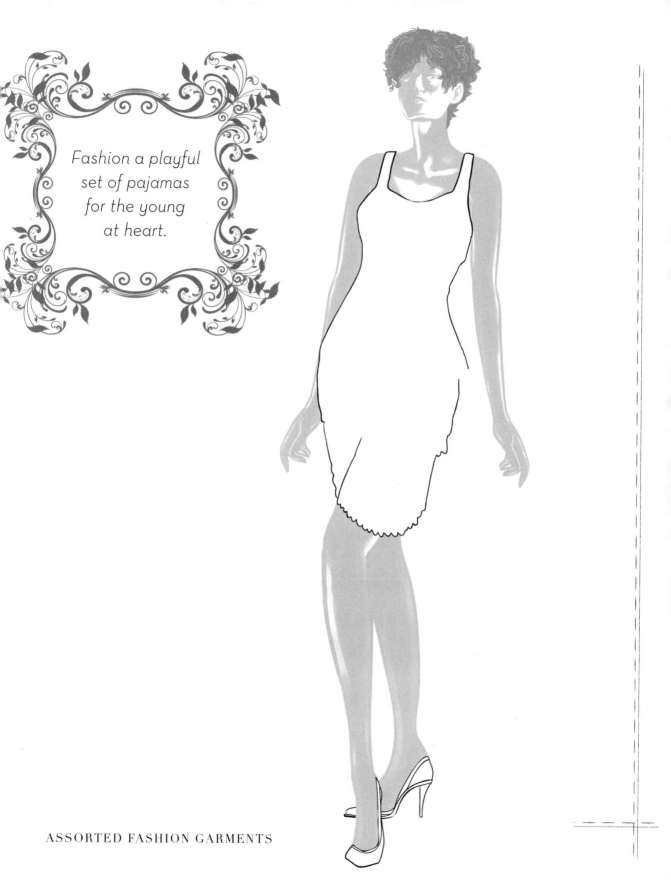

Fashion a playful
set of pajamas
for the young
at heart.

ASSORTED FASHION GARMENTS

Shoes & Hats

"Galop" Boots

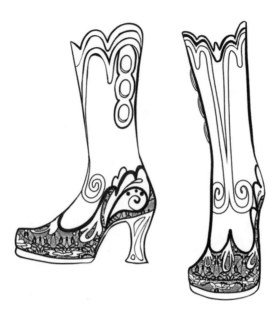

SEASON

Autumn

MATERIALS

Silk, satin, suede, and embroideries

INSPIRATION & STYLE

Jean-Louis Francois, Italian

Carousel Charm

As a part of any hunter's costume and travel wear, boots are essential to an outdoor wardrobe. Embroidered on this exquisite pair of suede boots are ornate vinelike patterns with delicate spool heels.

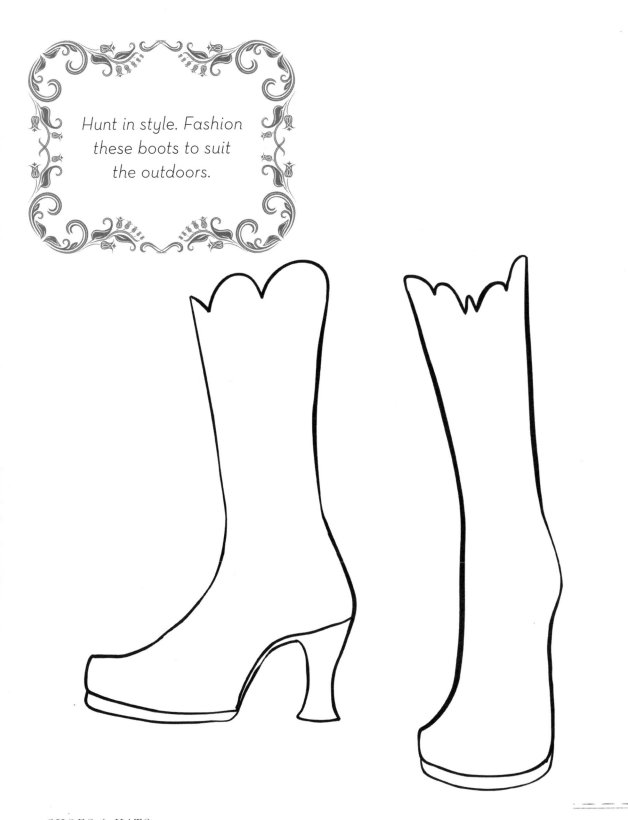

Hunt in style. Fashion
these boots to suit
the outdoors.

"Divus" Strap Shoes

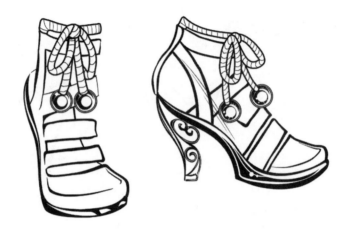

DATE & SEASON

Summer 1930

MATERIALS

Leather and ivory balls

INSPIRATION & STYLE

House of Chanel, Greek

Goddess Step

Influenced by costumes on the silver screen, the straps on these kitten-heeled shoes are designed similarly to Grecian sandals with their multiple straps and winding tendrils on the heel. Ornate ivory balls dangle from delicate strings tied around the ankles.

Stars and moviegoers alike would like to see a new pattern for these striking shoes.

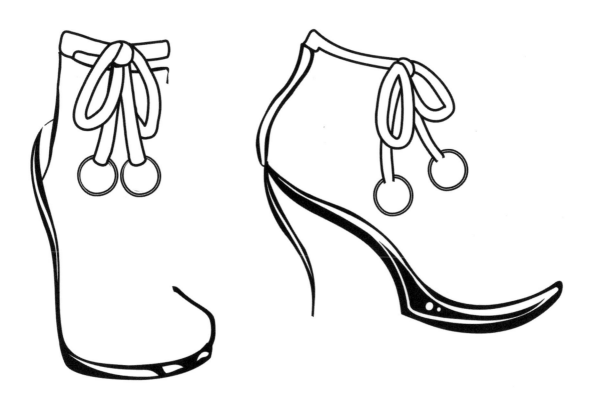

"Crystallum" Evening Shoes

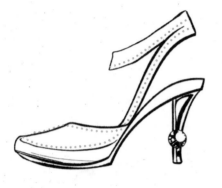
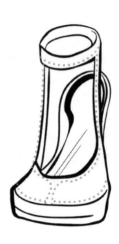

SEASON

Autumn

MATERIALS

Venetian glass, rhinestones, and metallic thread

INSPIRATION & STYLE

Christian Dior, Italian

Crystal Empress

Glimmering like the night sky, these gorgeous stilettos are a work of art. Each step glistens with embedded rhinestones decorating the open heel straps and edges of the shoes. Shimmering threads intertwine each stiletto, showcasing eye-catching Venetian glass near the base of the heel.

Showcase the intricate threadwork on these shoes in Milan with a breathtaking new design.

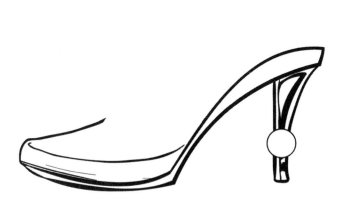

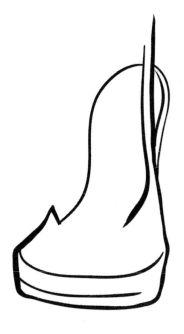

"Domina" Booties

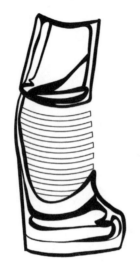
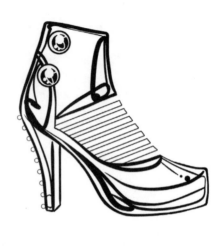

SEASON

Winter

MATERIALS

Leather and crystals

INSPIRATION & STYLE

Michael Kors, American

Gothic Cosmo

Among shoes, pumps and boots are classics that could be worn for nearly any occasion. This pair of booties combines the elegance of pumps with the edginess of boots with its low-cut leather front and crisscrossing crystal-studded straps. High stiletto heels and matching studded ankle straps makes these daring shoes stand out even in a crowded concert hall.

Concert divas are looking for mesmerizing shoes to accompany their outlandish costumes. Fashion a zealous pair of booties.

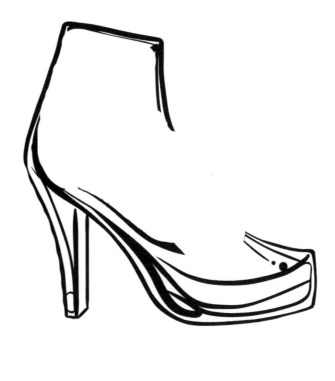

"Cavea" Wedged Boots

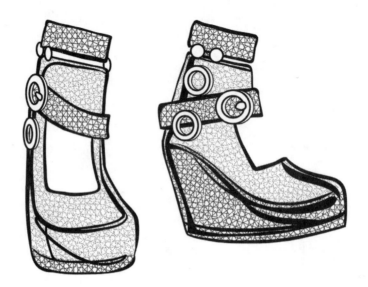

SEASON

Summer

MATERIALS

Leather and buckle

INSPIRATION & STYLE

Alexander Wang, American

Modern Grace

As exciting as social events are, oftentimes a relaxing day out is a much-needed breather. These leather wedged boots are ideal for a casual stroll. The delightful circular buckle gives the boots an endearing appearance without the showy use of stones and ornate designs.

Vacationing celebutantes are looking for a charming set of shoes to saunter down the beach boardwalk. Create a design fitting for a coastal break.

SHOES & HATS

"Fae" Pumps

SEASON

Winter

MATERIALS

Crystals and lamé

INSPIRATION & STYLE

Alexander McQueen, English

Cinderella

Waltzing across the dance floor, these extravagant pumps shine with gleaming crystals lining their wispy tendril straps. The radiant stones glitter with each twirling step, captivating the watching audience.

All girls dream of being a princess at one time or another. Let them live the dream by making their desired glass slippers.

"Tartessos" Lace Headband

DATE & SEASON
Summer 1920

MATERIALS
Lace, beads, and chiffon rose

INSPIRATION & STYLE
Paul Poiret, Greek

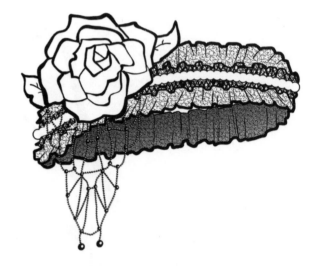

Ceres Flora

Wide headbands were originally used as a method to cure headaches by wearing it tightly over the head. By the 1920s, headbands were worn as accessories with embellished designs. This lacy headpiece adorned with dangling beads beneath a blossomed rose is often a part of a flapper's attire.

Flappers are looking for a spirited headband, Design a headpiece suitable for wild dances.

"Bellan" Cloche Hat

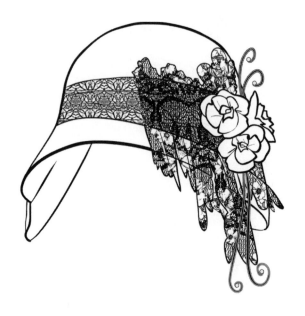

DATE & SEASON
Autumn 1920

MATERIALS
Cotton, satin, and camellia flowers

INSPIRATION & STYLE
House of Lanvin, American

Camellia Perfection

Popularly worn with short hair, the cloche hat tastefully frames the face with its conforming design. A bouquet of camellias decorates the side of this classy topper with a thick satin sash wrapped around the base.

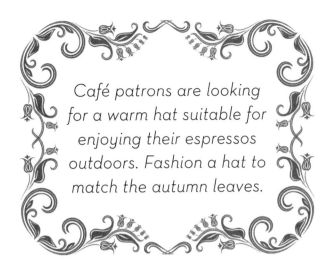

Café patrons are looking for a warm hat suitable for enjoying their espressos outdoors. Fashion a hat to match the autumn leaves.

SHOES & HATS

"Riet" Summer Hat

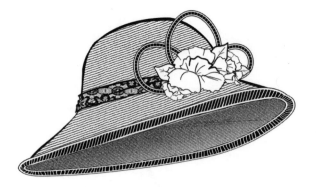

DATE & SEASON

Summer 1960

MATERIALS

Straw weave, satin, polka-dot ribbons, and carnation flower

INSPIRATION & STYLE

House of Gucci, American

Malibu Sea Breeze

As summer sets in, a visit to the beach is a must. Summer hats excel in keeping the wearer cool while still remaining fashionable. Tied around this hat is a fine satin ribbon with a supple carnation. Shaped around the flower are polka-dotted ribbons arched like petals.

Color Me COUTURE

Sunbathers basking in the sea breeze are looking for a stylish new hat to match their swimsuits.

"Whimsy" Bow Hat

SEASON

Autumn

MATERIALS

Felt, ribbon, and lace

INSPIRATION & STYLE

*Cristóbal Balenciaga,
American*

Sweet Innocence

*Modeled after the cloche hat, this whimsical
chapeau is dominated by a large bow
with a ring in the middle. The draping
ribbon beneath the bow is hemmed with a
matching lace on the hat's waved hem.*

COLOR ME **COUTURE**

Loving mothers are looking for a playful hat that their daughters will cherish.

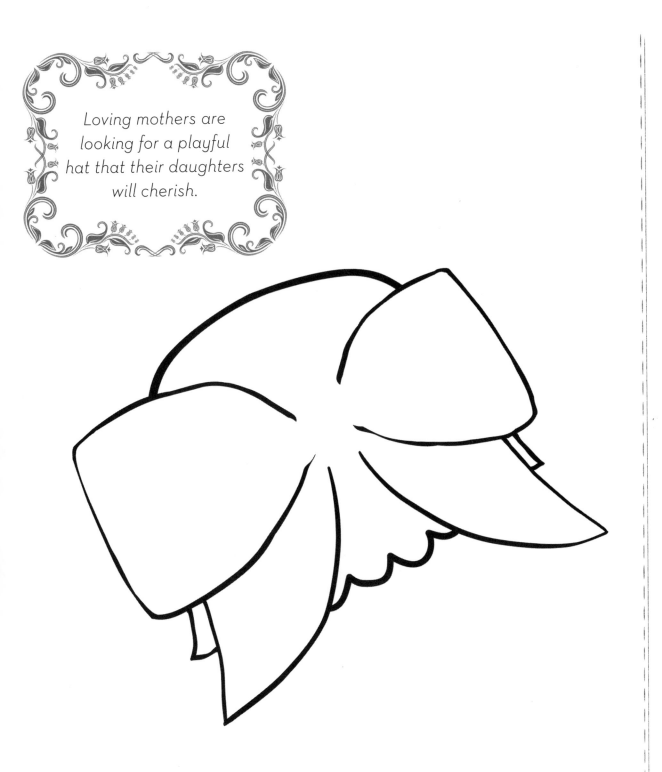

SHOES & HATS

Acknowledgments

As my best friend and I sat in the back of our high school classroom, we dreamed of writing and illustrating a "real" book together. With *Color Me Couture*, our dream has actually come true. I would like to thank my best friend Catherine Mong for her invaluable research, for her persistent reminder that everyday brings a deadline, and for delivering her very best efforts to the creation of th is book.

I wish to acknowledge the contribution and effort provided by Claire Chun and all of the designers and editors for *Color Me Couture*. I extend my sincerest gratitude to my publishers at Ulysses Press. And I offer my special thanks to Keith Riegert, for offering me the opportunity to share and express my love of art, history, creativity and fashion with all of you.

I would like to state my appreciation to Heidi Younger for generously sharing her time and offering great professional advice.

I wish to express my very special thanks to Yun Kuang for her encouragement and support. Additionally, I extend my sincerest thanks to I.L. Yuu for providing me with so much inspiration, love, and for always pushing me forward with a smile when my spirits were low.

I would like to thank my aunt, Gloria "Cuqui" Collazo for helping me maintain domesticity. I am very grateful to my aunts Anilda Rivera and Lydia Collazo for encouraging me achieve my ambitions. And I extend very special thanks my dearest friend Lucy Virola, for her tireless efforts to help my family in our time of need.

I extend my deepest gratitude to my brother and sister, David Collazo and Dina Collazo for standing with me, truly believing in me, and inspiring me to greatness.

And last but not least, I would like to thank my grandmother, Gloria Maria "Mami" Pages for her continuous love, for raising me to be the very best I can be, and for teaching me not to fear the unsteady road traveled when chasing your dreams.

About the Contributors

Gloria Collazo graduated from Fashion Institute of Technology. She is a freelance illustrator specializing in editorial illustration, concept art, and fashion illustration, among other areas. Her interest in clothing designs began at an early age with homemade dresses crafted by her grandmother. She currently lives in Brooklyn, New York.

Catherine Mong graduated from the Weissman School of Arts and Sciences in Baruch College. She is a freelance writer with a fond hobby in cosplay. The hobby stemmed from her childhood when her mother, a seamstress, customized a number of her outfits. She previously worked in the garment industry. She currently lives in Brooklyn, New York.